The Art of
Gordon Bennett

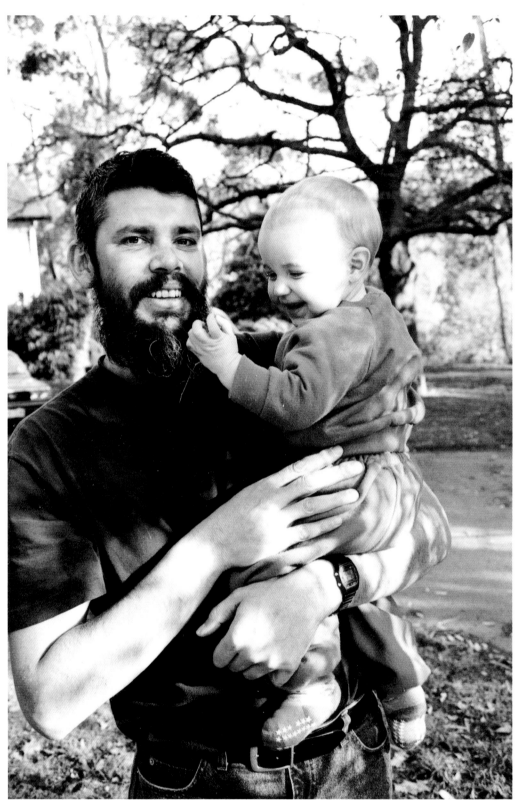

Gordon and Caitlin Bennett, Melbourne 1993

The Art of
Gordon Bennett

Ian McLean
Gordon Bennett

CRAFTSMAN HOUSE
G+B ARTS INTERNATIONAL

Distributed in Australia by Craftsman House,
20 Barcoo Street, Roseville East, NSW 2069
in association with G+B Arts International:
Australia, Canada, China, France, Germany, India,
Japan, Luxembourg, Malaysia, The Netherlands,
Russia, Singapore, Switzerland, United Kingdom
United States of America

ISBN 90 5703 22 1X

Design Craig Peterson/Vivian Chang: Handpress Graphics
Printer Tien Wah Press, Singapore

Contents

For Caitlin,
for her spirit
and her life.

Acknowledgements

I would like to acknowledge Ian McLean for his encouragement, dialogue and invaluable critical feedback over the enduring months of writing these manuscripts. Ian consistently demonstrated untiring patience and lucid observations.

My heartfelt gratitude to Leanne who gave her support, critical editorial assistance and attention to all of the details required to realise this publication. Also to our daughter Caitlin my deep appreciation for her understanding and patience beyond her years during a sometimes trying period.

My thanks to my mother, Grace, for her dialogue and feedback concerning the accuracy of her personal life experiences and family history.

I would also like to sincerely thank Bob Lingard and Fazal Rizvi for their careful reading of both manuscripts and for their valuable insights, comments and intelligent suggestions.

My thanks also to my gallerists Peter Bellas and Irene Sutton of Bellas Gallery, Brisbane and Sutton Gallery, Melbourne respectively, and their office support staff Simon Wright and Katrina Fraser, who gave of their time and expertise in securing the numerous images to accompany the manuscripts, and who gave encouragement throughout the process.

Grateful acknowledgement is also extended to all the people who have supported me and my work, and to the people in the following organisations who assisted in the realisation of transparencies required for this publication: Queensland Art Gallery; Art Gallery of Western Australia; University of Queensland; Heytesbury Holdings, Western Australia; Downlands College, Toowoomba, Queensland; and Parliament House Collection, Canberra. Special thanks to Deborah Hart whose persistence and efforts were greatly appreciated.

And finally to Craftsman House publishers, in particular the publishing director, Nevill Drury for his encouraging words and professional assistance with this publication.

Gordon Bennett

The initial research for my essay was undertaken in 1993 as part of my PhD thesis through the Department of Fine Arts at the University of Melbourne. I would like to thank Emeritus Professor Bernard Smith for his excellent supervision, the School of Art, University of Tasmania for giving me twelve months study leave, the Centre for Australian Studies at the University of Melbourne for generously providing me with an office, and Paul Carter for allowing me to use his office at the centre. Thanks also to my colleagues, students and various conference delegates for their feedback, and Jean Fisher of Third Text who first published some of my thoughts on Gordon Bennett's work.

While the opinions and oversights contained in my essay are entirely my own, the insights they contain would not have been possible without the close critical relationship that I have enjoyed with Gordon and Leanne Bennett.

Closer to home, I must express my thanks for the different but equally essential support received, in order of age, from Levi, Inci, Paris, Lena, Sumia, Shirley and Bob.

Ian McLean

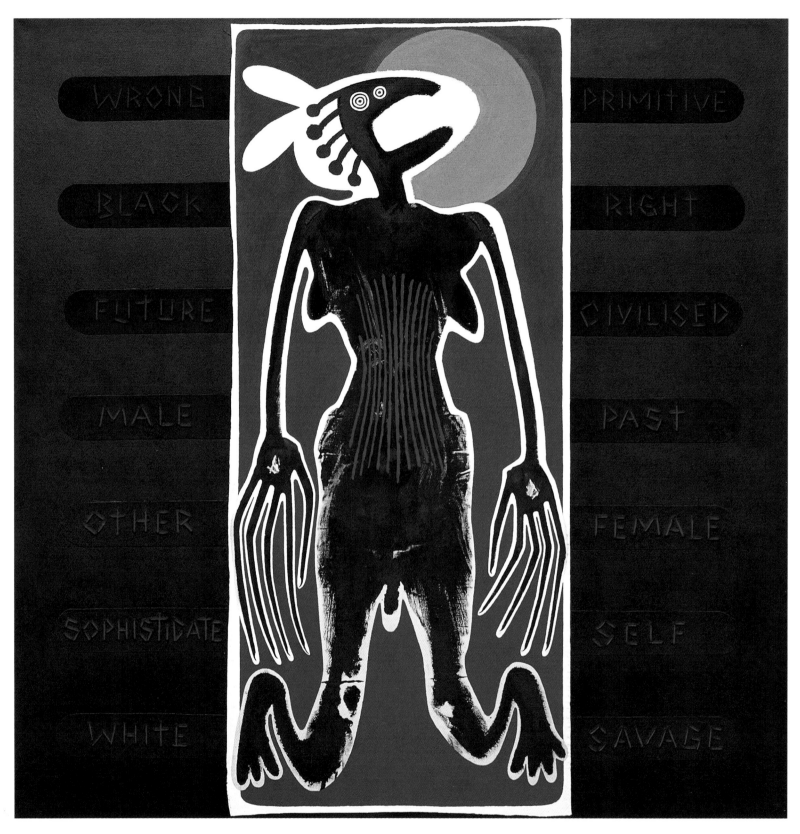

Plate 1
1994
Altered Body Print (Shadow Figure Howling at the Moon)
182 x 182 cm
Acrylic and flashe on canvas
Collection: Private. Photo: Phillip Andrews

The Manifest Toe

Gordon Bennett

More rights for Aboriginals? Well, I think everybody, not everybody but many people in high places, have gone mad. I always maintain that if an Aboriginal came and held his bare toe up, they'd lick it. And you can write that if you like.

Sir Joh Bjelke-Peterson, Former Premier of Queensland, 1986.[1]

So instead of everyone wearing bowler hats and speaking pidgin English we face peoples clinging to their own heritages, traditions, languages, and styles of selfhood, insisting that they be written into history as themselves, and that their picture of us, with elements we might not relish, be written into that history too.

Thomas McEvilley.[2]

Prologue:

There came a time in my life when I became aware of my Aboriginal heritage. This may seem of little consequence, but when the weight of European representations of Aboriginal people as the quintessential primitive 'Other' is realised and understood, within discourses of self and other, as a level of abstraction with which we become familiar in our books and our classrooms, but which we rarely feel on our pulses[3]; then you may understand why such an awareness was problematic for my sense of identity. The conceptual gap between my sense of self and other collapsed and I was thrown into turmoil.

It is the collapse of the conceptual gap between the binary opposites of self/other, civilised/savage, sophisticated/primitive, or perhaps more appropriately its gradual disintegration and my process of integration, that forms the substratum of my life and work. Consequently I am interested in psychoanalysis; particularly in the kind of radical analysis that interprets the so called norms of society as repressive illusions and which regards analysis as a preparation for the analysand to get outside them once and for all. The aim of radical analysis is to foster the strength to deal with the effects of such a break — rejection, hostility, fear and anxiety — and to live creatively with the diversity of meanings outside set judgements.[4]

Michel Foucault was a thinker whose critical analysis of 'systems of thought', and how they maintain their hold over us, articulates what has been a central issue for me; there is

Figure 1
1992
Gone Primitive
23 x 16 cm
Book, photograph, plastic, cord
Collection: Private
Photo: Gordon Bennett

Plate 2
1992
History Painting (Burn and Scatter)
92 x 65 cm
Acrylic and flashe on canvas
Collection: Holmes à Court
Photo: Courtesy Heytesbury

nothing 'natural' or given about our membership in social groups. He asked the question 'how [do] we *recognise* ourselves as a society, as part of a social entity, as part of a nation state?'[15] If I were to choose a single word to describe my art practice it would be the word *question*. If I were to choose a single word to describe my underlying drive it would be *freedom*. This should not be

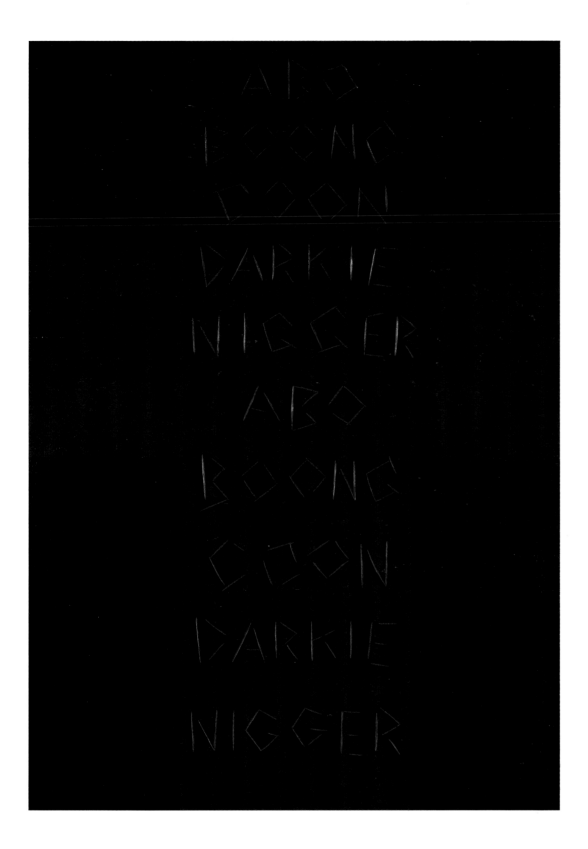

Plate 3
1992
History Painting (Excuse My Language)
92 x 65 cm
Acrylic and flashe on canvas
Collection: Holmes à Court
Photo: Courtesy Heytesbury

regarded as an heroic proclamation. Freedom is a practice. It is a way of thinking in other ways to those we have become accustomed to. Freedom is never assured by the laws and institutions that are intended to guarantee it. To be free is to be able to question the way power is exercised, disputing claims to domination. Such questioning involves our 'ethos', our ways of being, or

Above: Figure 2
1992
Self Portrait (Vessel)
Size variable
Mixed media
Courtesy Bellas and Sutton Galleries
Photo: Gordon Bennett

Above right: Figure 3
1991
Panorama (Stream)
130 x 162 cm
Oil and acrylic on canvas
Collection: Private
Photo: Xavier Lavictorie

becoming who we are. To be free we must be able to question the ways our own history defines us.[6]

Antonio Gramsci, an Italian thinker and anti-fascist activist imprisoned by Mussolini, wrote that the starting point of critical elaboration is the consciousness of what one really is, and is 'knowing thyself' as a product of the historical process to date, which has deposited in you an infinity of traces without leaving an inventory.[7] An 'infinity of traces without an inventory', those few words best describe for me an identity, a concept of self, which involves a process of creative flux — a remembering of experience, knowledge and history from the many diverse culturally relative, dismembered, and repressed fragments, an ever flowing process that is alive with possibilities, and which confuses and flows through and around the conceit 'I am'.

A Personal History

The passing of the "Aboriginals Protection and the restriction of the Sale of Opium Act" in 1897 was the Queensland Government's first major involvement in the lives of the colony's indigenous peoples. This Act was the first comprehensive protection and segregation Act in Australia and resulted in the Queensland Government exercising wide-ranging control over the

Figure 4
1988
Untitled (Detail of Triptych)
38.5 x 57.5 cm
Mixed media on paper
Collection: Queensland Art Gallery
Photo: Gordon Bennett

lives of individual Aboriginal and Torres Strait Islander people. The Act was not replaced until 1939, with the creation of two Acts, the 'Aboriginal Preservation and Protection Act', and the 'Torres Strait Islanders Act'.[8]

A subtle Policy shift occurred at this time from one of protection and segregation, that had characterised the period since 1897, to one of 'protection and preservation' that was to characterise the period from 1939 to the next major piece of legislation in 1965. The 1939 Act, however, meant little change for Aboriginal people and, in fact, meant that the Director of Native Affairs was given increased powers in relation to Aboriginal property, Aboriginal Courts, police and gaols, and this increased power was also extended to Superintendents on reserves.[9]

My mother was born in St George in 1934 and was subject to the provisions of these Acts, as was her mother and her people. Grace Bradley grew up on Cherbourg reserve in south east Queensland, 240 kilometres northwest of Brisbane. As an orphan from the age of five, she never really knew her own mother and father, or her mother's country, language or customs, as all

Plate 4
1989
Ancestor Figures
148 x 236 cm
Oil on canvas
Collection: Private
Photo: Phillip Andrews

cultural manifestations of the various Aboriginal groups present at Cherbourg were officially forbidden. Grace is reluctant to talk of her life at the 'dormitory', a home for young girls and women, but has told me a little of the raids on garbage bins, and on the superintendent's orchard she and the other children would go on to supplement the dormitory diet, and of the practice of shaving girl's heads for punishment.

At the dormitory domestic science school my mother was taught domestic skills and was sent to work for a middle class family. After proving that she could live successfully with 'white' people for a period of three years she was able to secure an official exemption permit to leave the mission. The decision to grant an exemption was based on the ability of the person to manage their own affairs and their disassociation with people of their own race.[10] She went to live in the nearby town of Monto, 125 kilometres west of Bundaberg in south east Queensland, and managed to secure a job as a domestic at a local hotel. While working at the hotel she met my father, an Englishman working as a foreman electrical linesman for a large British construction company contracted by the Queensland Government.

Figure 5 and 6
1990
Psycho(d)rama. (Detail from installation)
Size variable
Mixed media
Courtesy Bellas and Sutton Galleries
Photo: Grace and Don Bennett

I was born in Monto on October 9 1955. At that time my mother still had to carry with her the official exemption certificate that gave her a limited freedom from the 1939 Act, and from the reserve. I say limited freedom because this 'dog tag', as Aboriginal people referred to it, could be revoked at any time and had to be produced on the demand of any police officer. My mother lived in fear of me being taken from her. I don't doubt for a second that she wanted for me a life that she had never had; a life that would never know the environment of a regimented institution. I was raised in a cultural climate where my mother was not even a legitimate citizen until I was twelve years old. It should be understood that it was not until 1967, the year my brother Bradley was born, that Aborigines were given the right to be counted in the national census as Australian citizens; this was accomplished through a national referendum.

Our family moved often, never settling in one place for long. Part of the reason for this

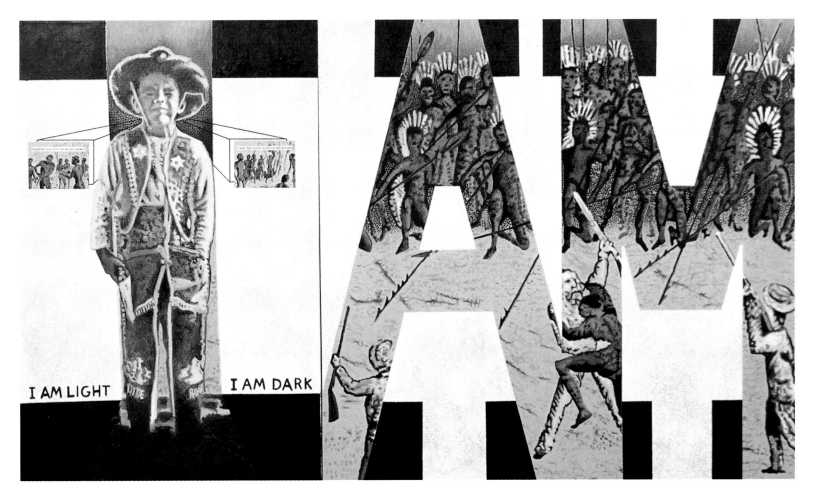

I AM LIGHT I AM DARK

Plate 6
1990
*Self Portrait (But I Always Wanted
to be One of the Good Guys)*
150 x 260 cm
Oil on canvas
Collection: Private
Photo: Phillip Andrews

itinerant lifestyle was my father's job erecting high tension electrical towers taking electricity to Queensland country towns. In the four years after I was born we covered a lot of territory living mostly out of caravans. I don't remember any of it however, and I look at the photographs of myself as a child as if it were someone else. I've been told that I used to like wandering off by myself exploring the countryside, much to the distress of my parents. At some point my father joined the Australian army and we moved to Melbourne in 1959–60.

In Melbourne the itinerant lifestyle persisted, as indeed it would for another eighteen years. At first we lived in inner city Richmond, then at the beach in suburban Frankston and Mornington where my earliest childhood memories begin. Eventually we moved to Sunbury, a country town approximately thirty-four kilometres west of Melbourne, where I began my first two years of primary school. I did well in reading and comprehension and I have vague memories of finger painting, but I think that may have been kindergarten in Mornington. I remember that I was also good at running away from school and was punished often for doing so.

Both my parents enjoyed reading, indeed my mother educated herself to a large extent as she received only a limited education at Cherbourg. I don't know much about my father's

Opposite: Plate 5
1992
Self Portrait (Ancestor Figures)
Size variable
Mixed media
Courtesy Bellas and Sutton Galleries
Photo: Phillip Andrews

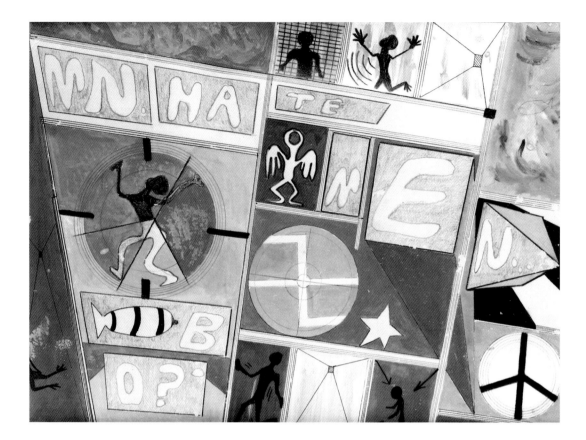

Figure 7
1968
Untitled
26 x 35.5 cm
Mixed media
Collection: The Artist
Photo: Richard Stringer

education except that, late in life, he once confided to me that he had aspirations of going to art school. He often said how he would make elaborate stages out of cardboard and put on puppet shows for his seven brothers and sisters. His father was a Sergeant Major in the British army and had served in colonial India. My father was in the Sea Cadets when he was fifteen or sixteen, and when the second world war started he lied about his age to join the navy. Art School aspirations were left far behind.

My father died in 1987, during my second year of Art College. We disagreed on many things, including his sometimes racist beliefs about Aboriginal people and cultures. I talked with him about it before he died and came to understand this as a reflection of his European upbringing, and of the attitudes of the broader so-called 'mainstream' community during his life in Australia. I have nothing but respect for him in that he stayed by us, and looked after us to the best of his ability, sometimes working up to three jobs at a time, along with my mother who worked as a domestic, and in a clothing factory, in order to support us and make ends meet.

I grew up a shy introverted child, self-conscious and timid. I grew used to my own company and tight family circle and developed an active and creative imagination. The itinerant lifestyle we led was not conducive to forming lasting relationships with people. I don't remember any Aboriginal faces as I grew up and I never considered myself any different from my peers. At primary school from grades three to six, having moved again to a school in the

small town of Diggers Rest about four kilometres closer to Melbourne than Sunbury, I proved to be a good runner, high jumper and long jumper. This brought the approval of both school and peers at inter-school sport carnivals.

I was an average student and did well in English, Art and Social Studies. In fact my Social Studies books were often used as examples of student work by the School Principal who also taught grades three through to grade six, all of us in the same room. Grades one and two were in an adjoining room with their own teacher. I had given up running away from school by the time I reached grade three, but I remember going for long walks across the surrounding paddocks with only the sheep for company.

We stayed in Diggers Rest until I began secondary school in Sunbury. My father was out of the army by then and we ran a family business. It was a Mobil service station and we all pitched in to help. My mother cooked and served tables in the attached café/restaurant. In the afternoon and on weekends I served behind the counter and did other general duties like chopping wood for the kitchen stove. We had our first television set. I was eleven years old and my mother was pregnant with my brother when we moved once again. This time it was back to Queensland and another Mobil service station in Nambour in the Sunshine coast hinterland just north of Brisbane. It was early 1966 and I remember that we moved twice in four years within Nambour itself.

Sometime during my last years at Nambour High School I painted a small painting which now seems quite prophetic in that I had used text, one point perspective, abstract and figurative elements as well as hard edge geometry, coupled with more painterly aspects, and a content that is concerned with alienation and race relations. I remember that I tried to disguise the text by leaving out some of the letters to avoid the usual criticism from my parents of 'why don't you paint normal paintings instead of weird ones'. The text was meant to read 'Men hate Men' and the 'B' and 'O' referred to the threat of nuclear holocaust.

Art was my best subject at high school, followed by Geography and English. I remember that I was interested in the work of Bosch and Bruegel and I suppose that I was indeed influenced by such 'weird' painters. I was also amazed by the work of Jackson Pollock and did my own versions of his style, none of which survive. I had a dislike of the illusion and 'rules' of perspective, and for representational art, preferring to work with my imagination and an idea as a point of departure. However art classes at school were quite 'dry' in that there was a focus on remembering by rote particular dates and architectural styles.

I completed secondary school to junior level and soon after left Nambour for Brisbane at age fifteen for an apprenticeship as a Fitter and Turner, following my father's advice to 'get a

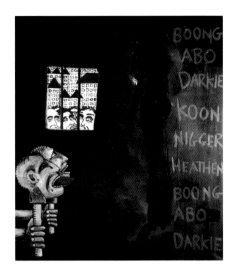

Figure 8
1987
The Persistence of Language
(detail of right panel)
152 x 137 cm
Acrylic on canvas
Collection: Art Gallery of Western
Australia
Photo: Courtesy Art Gallery of Western
Australia

Trade'. In 1970 there was little work around for young school leavers in Nambour, so rather than wait to go on the dole I applied for a job in Brisbane. I was successful and moved into an inner-city boarding house where I lived for the first year of my apprenticeship. I was caught shoplifting a paint set from a major department store later that year. My family moved down to the outer northern suburbs of Brisbane soon after; I think they feared I was going off the 'rails'.

I finished my apprenticeship in 1975 and promptly left my trade behind to join the Australian Telecommunications Commission (Telecom) as a trainee Line serviceman. At this time I met and fell in love with Leanne and we were married in 1977. Eventually I came to a point where I had reached the limit of promotional avenues available for what I thought were my capabilities. I saw only years of drudgery ahead of me doing the same thing day to day and finally decided to leave job security behind and go to Art College. It was not an easy decision to leave Telecom. At first I studied Acupuncture for six months at night school before deciding that I didn't want to continue down that path. Acupuncture did increase my appreciation of Taoism however, and I guess I chose to try that particular profession as my way out of Telecom because I already had an interest in the martial arts, which I took up shortly after being attacked and beaten with a pick handle by a drunken 'white' man in 1978. I was later drawn to the philosophical aspects of the martial arts more than the physical side.

I finally settled on art as my way out. In 1985, after taking art classes at night for two years, I took my portfolio and applied for entry to Art College as a 'mature age' student. Thankfully I was accepted into the second Brisbane College I applied to, after being refused entry to one other. I began Art College in 1986.

The Voyage Out

The process of assimilation into the dominant colonial culture of Euro-Australia was completed over at least three generations of my mother's family. The experiences of my great-grandmother and grandmother may never be known, but it is a fact of my life that this process of assimilation was completed by my mother and inherited by me. My upbringing was overwhelmingly Euro-Australian, with never a word spoken about my Aboriginal heritage. I first learnt about Aborigines in primary school, as part of the social studies curriculum. The history I was taught was the history of colonisation. A school history primer, written in 1917, reads in its opening passage:

> When people talk about 'the history of Australia' they mean the history of the white
> people who have lived in Australia. There is a good reason why we should not stretch the

term to make it include the history of the dark-skinned wandering tribes who hurled boomerangs and ate snakes in their native land for long ages before the arrival of the first intruders from Europe . . . for they have nothing that can be called history. They have dim legends, and queer fairy tales, and deep-rooted customs which have come down from long, long ago; but they have no history, as we use the word. When the white man came among them, he found them living just as their fathers and grandfathers and remote ancestors had lived before them . . . Change and progress are the stuff of which history is made: these blacks knew no change and made no progress, as far as we can tell. Men of science may peer at them and try to guess where they came from, how they got to Australia, how their strange customs began, and what those customs mean; but the historian is not concerned with them. He is concerned with Australia only as the dwelling-place of white men and women, settlers from overseas. It is his business to tell us how these white folk found the land, how they settled in it, how they explored it, and how they gradually made it the Australia we know today.[11]

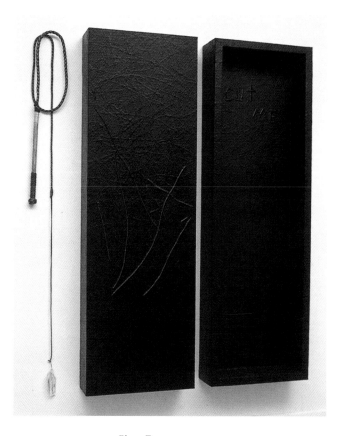

Plate 7
1993
Self Portrait: Interior/Exterior
Each panel: 187 x 60 x 25 cm
Mixed media
Collection: The Artist
Photo: Phillip Andrews

By the 1960s, when I began third grade in primary school very little had changed. In the two room school in Diggers Rest I learnt that Aborigines had dark brown skin, thin limbs, thick lips, black hair and dark brown eyes. I did drawings of tools and weapons in my project book, just like all the other children, and like them I also wrote in my books that each Aboriginal family had their own hut, that men hunt kangaroos, possums, and emus; that women collect seeds, eggs, fruit and yams. The men also paint their bodies in red, yellow, white and black, or in feather down stuck with human blood when they dress up, and make music with a didgeridoo. That was to be the extent of my formal education on Aborigines and Aboriginal culture until Art college.

I can't remember exactly when it dawned on me that I had an Aboriginal heritage. I generally say that it was around age eleven, but this was my age when my family returned to Queensland where Aboriginal people were far more visible. I was certainly aware of it by the time I was sixteen years old after having been in the workforce for twelve months. It was upon entering the workforce that I really learnt how low the general opinion of Aboriginal people was. As a shy and inarticulate teenager my response to these derogatory opinions was silence, self-loathing and denial of my heritage.

Over the fifteen years I spent in the workforce, and as I listened to the majority of my

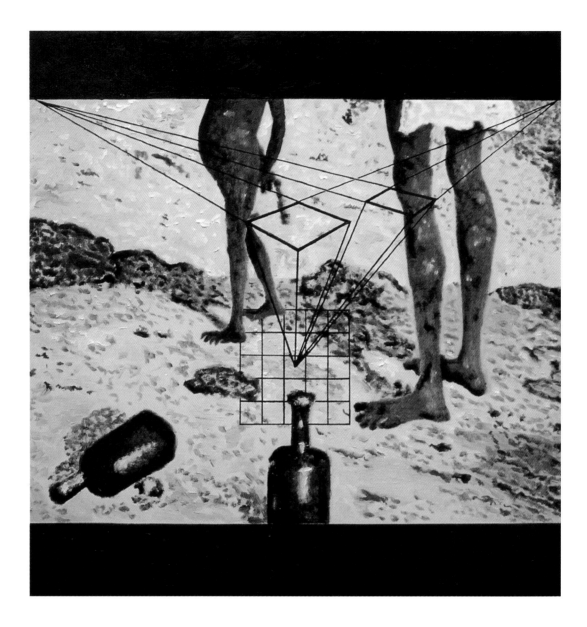

Plate 8
1989
Web of Attrition (Detail No 1)
One panel of five: 100 x 100 cm
Oil on canvas
Collection: National Gallery of Australia,
Canberra
Photo: Phillip Andrews

peers and workmates talk about the 'abo's', 'boongs' and the 'coons', as Aborigines were usually referred to, I felt more and more alienated. On the surface I would sometimes smile, maybe nod my head to indicate that I was participating in the general conversation, that I was part of the group, trying to fit in as best as I could. The thought never crossed my mind that they might be wrong, or that I should, or even could, challenge these opinions.

Quite apart from being shy and inarticulate, all the education and socialisation upon which my identity and self worth as a person, indeed my sense of 'Australianness', and that of my peers, had as its foundation the narratives of colonialism. I had never thought to question those narratives and I certainly had never been taught at school to question them . . . only to believe them. Neither had I thought to question the representation of Aborigines as the quintessential 'primitive Other' against which the 'civilised' collective 'Self' of my peers was measured.

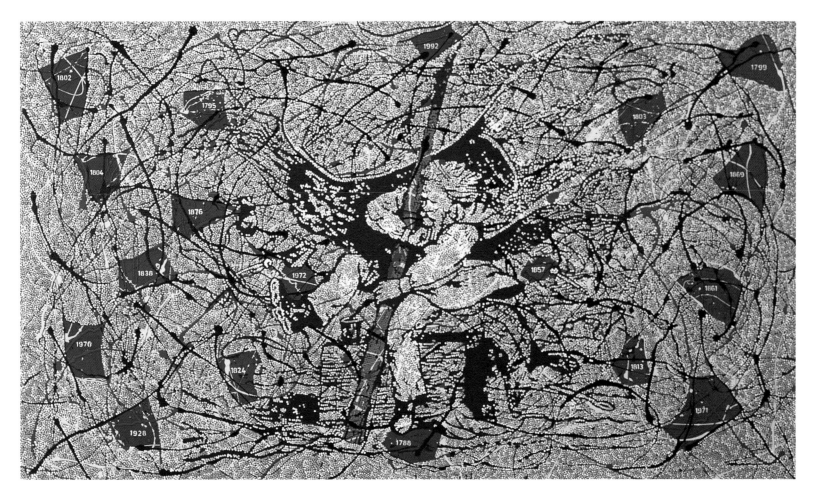

Plate 9
1992
*Myth of the Western Man
(White Man's Burden)*
175 x 304 cm
Acrylic on canvas
Collection: Art Gallery of New South
Wales
Photo: Vesna Kovac

Aborigines are imagined by 'white' Australians within a powerful and seemingly inescapable whirlpool of 'civilisation' and 'savagery' which engage European representations of Aborigines in a type of tautology. Being a negative transgressive image of civilisation, the grotesque formulation of the 'savage' lacks any positivity — whether paraded in the masks of the noble, comic, or ignoble. All are found in the same exotic places and with the same dark skin — expressions of the same semiotic formula by which the colonised have another's struggle for identity thrust upon them.[12] The dominant myth of Australia was the history of exploration and colonisation; the spirit of the explorer, the pioneer, and the settler was a spirit all Australians could share in. Such was the unproblematic sense of national identity I was taught to believe in. This Australian identity that so effectively colonised my mind and body was presumed to be a white experience; informed as it was by the colonial diaspora of an essentially Western culture.

I had been taught to believe in this identity and its foundations; everyone around me seemed to believe it too, and everything I saw on television or read in the newspapers also reflected it. Living in the northern suburbs of Brisbane with Leanne, our main concerns were chasing the 'Australian Dream' of buying and eventually owning our own house and raising

Above: Figure 9 and 10
1993–94
Home Sweet Home
Two panels each: 27.5 x 19 cm
Watercolour and pencil on paper
Collection: Private
Photo: Gordon Bennett

Home sweet home 30·9·93 10·37 AM.
Please excuse me I don't mean to offend. I was just reflecting on the "great Australian dream". Leanne and I own our house in the outer northern suburbs of Brisbane. We saved like crazy to pay it off. All that time getting up in the morning and going to work, coming home, going to work, coming home, going to sleep and getting up again, like clockwork toys. Spending weekends in the garden, mowing, maintaining the house. We put a lot of time and effort into it – but for what? So I could go to the back yard barbie with the neighbours, have a sense of community, have children, get drunk, watch T.v. I think it was the barbeques that got to me in the end. The party talk both at work and around the neighbourhood. The subject of Aborigines always came up. It was then that I felt an outsider. I could not fit in. The bloody boongs, the fucking coons, abo's, niggers – put them in a house and the first thing they do is burn it down. Try and imagine what it's like, sitting quietly, listening to this shit while your stomach turns in knots – try to fit in, keep the peace, after all you live right next door, right? Who needs to be a target for all that bullshit – life's tough enough as it is. So, there I sit, in a quiet rage, hoping no-one will notice my tan, my nose, my lips, my profile, because if I start trouble by disagreeing, then that would be typical of a damn coon wouldn't it? J Bennett 10·54 AM.

children, bringing them up within the social structure and culture with which we ourselves had grown up. But, my growing feelings of alienation became intolerable.

It's important to understand that the position people hold in this society and the jobs they perform play an important role in the conceptions they form of themselves. The centre of it all is their job and corresponding social position. Their identity, or sense of continuity in their experience at any moment, is in being someone somewhere performing a task, moving along a given life-cycle from child to adolescent, student, trainee, young parent, experienced worker, expert, parents whose children have left home, grandparents, senior citizens, and so on unto death.[13]

Happiness, satisfaction, contentment and such emotions are dependent on accepting the terms of the life-pattern you have chosen. You must invest in the chosen path and believe totally

Shadow monsters from the id. 27·4·94

Please excuse me, I don't mean to offend. I was just remembering the many years I've spent living in the suburbs. All the parties I've been to, the barbeques, the discos and pubs etc. I've seen a lot of violence in my time, people drinking and becoming aggressive, punching out walls or each other. I've heard about the rapes, the murders, the robberies and general assaults. I've been the victim of violent assaults myself several times. In fact I learnt to feel unsafe in crowds of people and sometimes I'm still unable to enter a crowded room. I feel like an outsider sometimes, and even a victim. I see and hear all this violence in this society, but I see and hear another kind of violence that is just as prevalent. It's the psychic violence directed towards Aboriginal people and it disables and scars just as much as the physical violence that is perpetrated daily in the general non-Aboriginal community. I remember the abuse I've heard about us being drunks, violent, unable to look after our children, immoral, lazy, bludgers who can't seem to look after themselves, and more, much, much more, too much more. It seems to me that Aboriginal people are the dumping ground for all those human traits the non-Aboriginal community can't seem to accept in their own behaviour; all that is savage, uncivilised and even primitive (by their own definition) in their own behaviour, as can be seen in the daily newspapers and on T.V. It's like all that is repressed, pushed away to be unconsciously dumped onto Aborigines as the black shadow monsters from the id.

G Bennett 4.04 P.m.

Figure 11 and 12
1993–94
Shadow Monster from the Id
Two panels each: 27.5 x 19 cm
Watercolour and pencil on paper
Collection: Private
Photo: Gordon Bennett

in that investment before you can reap the benefits and see the value of your life experience. What do you do though, with the frustration suffered in conforming to that life-pattern? What do you do if the values promised for your labour are not forthcoming; you do not feel happiness, satisfaction, or great comfort in the sacrifice? What happens if even the money, or greater golden symbols, cannot compensate for what you feel you have lost?[14]

After fifteen years in the workforce my dignity and self-esteem were through the floor. Leanne and I were only two years away from owning our own house; but any satisfaction I felt was hollow. Leanne wanted to have children, but I didn't feel I could cope with the responsibility of parenthood. I didn't want to bring a child into the world to grow up in the same atmosphere of institutionalised racism I was experiencing. My experience was similar to that of Adrian Piper, an African-American conceptual artist with a fair complexion, who writes:

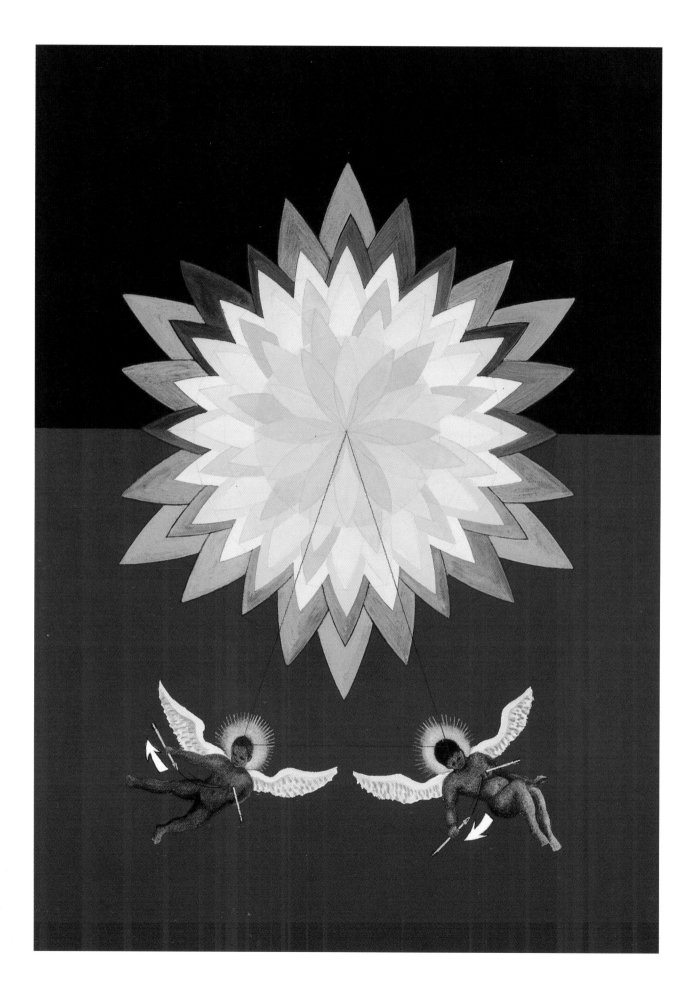

Plate 10
1990
Resurrection (Bloom)
37 x 27 cm
Watercolour on paper
Collection: Private
Photo: Phillip Andrews

Blacks like me are unwilling observers of the forms racism takes when racists believe there are no blacks present. Sometimes it hurts so much we want to disappear, disembody, disinherit ourselves from our blackness. Our experiences in this society manifest themselves in neuroses, demoralisation, anger, and in art.[15]

The early eighties were a time of great personal growth for me, a time of learning to believe in myself as a person and a time of reconstructing a self-image distorted by the 'mirror' of racist beliefs. I understood the need to stop denying and repressing my Aboriginal heritage. I found the courage and self confidence to quit my safe secure job and go to Art College.

The Voyage In

At Art College I somehow felt that I belonged. It was a haven, a world of ideas, theories and concepts ranging from the chemical structure of paint to the socio-psychological and political structure of human societies and cultures. It was the humanities electives that interested me most of all; communication theory, which taught me how to think critically, and art history (which I duly noted positioned the rock art of 'primitive' man as its foundation; 'progressing' through the Renaissance to Modernism) were compulsory subjects for the first year. However it wasn't until my postmodernism elective in second year that I really understood the full implications of what art college could mean for me.

I found the information I was absorbing liberating. I use the word 'absorbing' on purpose in order to establish a point on my relationship to theory. My interest in theory has been integral to my art, but I soon found that I could not verbalise my intuitions and understanding of the theories I was being exposed to. I could write well enough to demonstrate my understanding, and I was a straight honours student, but to talk theory was just beyond me; I was still that inarticulate teenager who had retreated into silence many years before. I found the language in which I was most articulate to be the visual language of painting, and it was through painting that I found a voice. Postmodernism was only one of my second year electives. I did two other electives in that year; Art Therapy and Personal, Interpersonal and Creative Development. The next year I chose as my electives Aboriginal Art and Culture, and Classicism.

The Aboriginal Art and Culture elective opened my mind to the complexity and sophistication of the many and varied indigenous Australian cultures, part of which was my own heritage; but which part? I didn't feel comfortable with depicting x-ray fish or kangaroos. I wanted to explore 'Aboriginality', if only to heal myself, but I felt that for me to paint fish and kangaroos and the like would have been like painting empty signs of this thing called 'Aboriginality'.

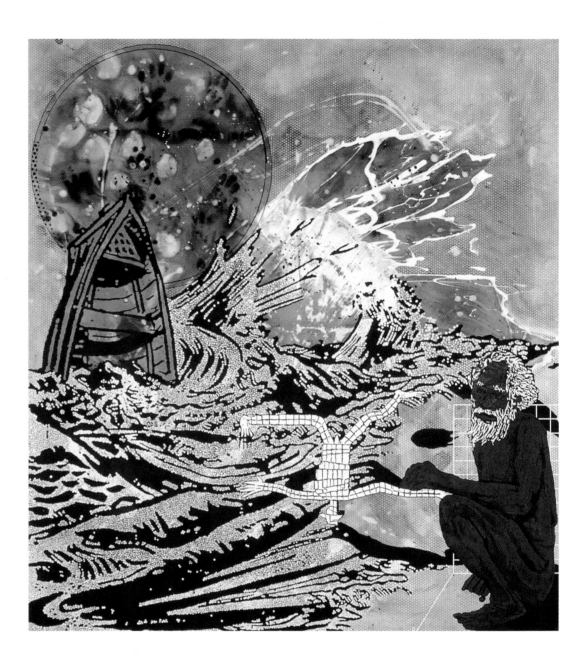

Plate 11
1994
Aborigine Painting (The Inland Sea)
216 x 197 cm
Acrylic on canvas
Collection: Private
Photo: Kenneth Pleban

Aboriginality, I soon discovered, was an ephemeral thing, something that could not be adequately pinned down to a set of particular characteristics although many people, both black and white still try. I see one of its manifestations as a kind of strategy, born out of a necessity, to conceive of a collective indigenous Australian identity that is in its essence non-white. This was supposed to give someone like me something seemingly solid to cling onto, a kind of life raft to keep from going under. I was told by many Aboriginal people that Aboriginality is in the heart. I interpret this as an underlying 'truth' that cannot be verbalised, save to say that it is an essence of shared experience, of pain and of loss and of the struggle to maintain human dignity in the face of a colonial onslaught that, as the Algerian post-colonial thinker Frantz Fanon observed:

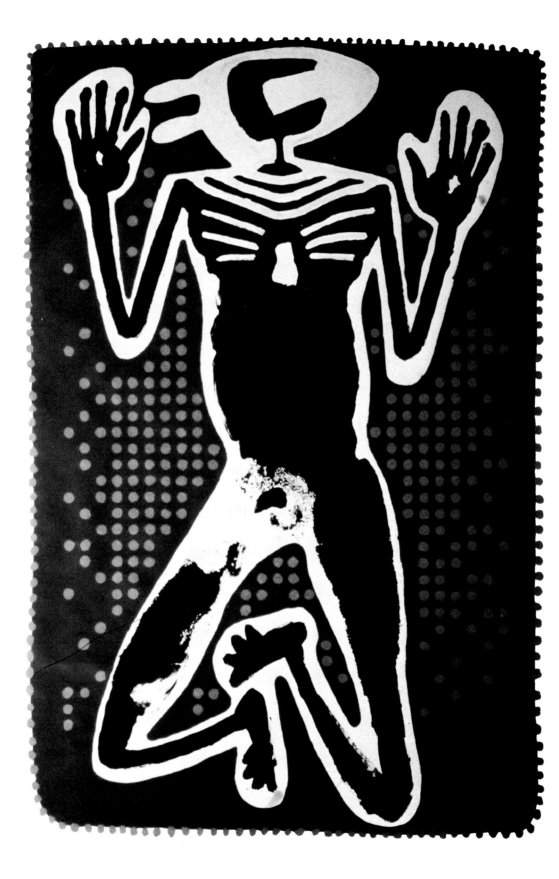

Above: Figure 14
1994
Surface Veil
38 x 38 cm
Mixed media on paper
Collection: The Artist
Photo: Richard Stringer

Figure 13
1994
Altered Body Print (Howl)
150.5 x 103.5 cm
Acrylic on paper
Collection: Downlands Toowoomba
Photo: Courtesy Downlands College

. . . is not satisfied merely with holding a people in its grip and emptying the native's brain of all form and content. By a kind of perverted logic, it turns to the past of oppressed people, and distorts, disfigures, and destroys it.[16]

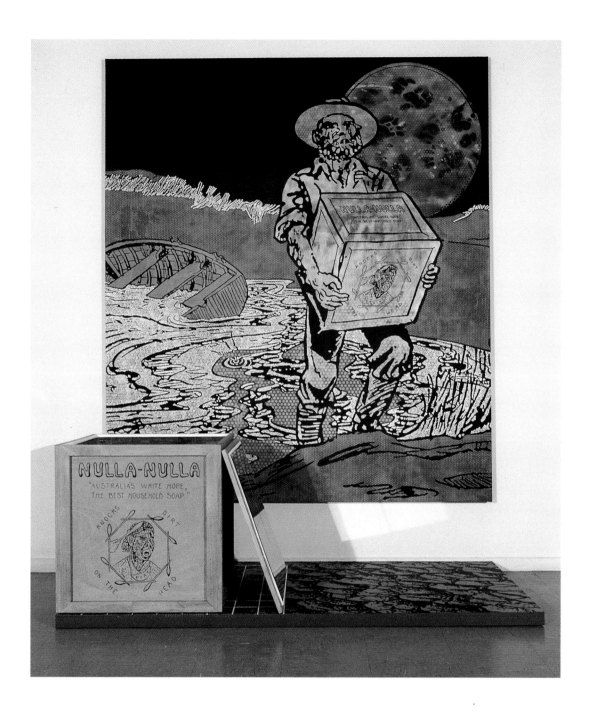

Plate 12
1994
The Aboriginalist
(Identity of Negation: Flotsam)
Size variable
Mixed media
Collection: Museum of Modern Art,
Heide
Photo: Kenneth Pleban

There are sound strategic reasons for investing in essentialist versions of Aboriginality because, in many ways, it's all we have; while white Australia has all the material and institutional support. However, I would contest the concept of Aboriginality being nothing more or less than a strategic logocentre for whatever purposes such a stratagem may be gainfully applied.[17] While I would concede that a strategic logocentre may be one of the manifestations that Aboriginality can take, I would also point to this kind of essentialist identity as being the object of what Fanon once called a:

> passionate research . . . directed by the secret hope of discovering beyond the misery of today, beyond self-contempt, resignation and abjuration, some very beautiful and

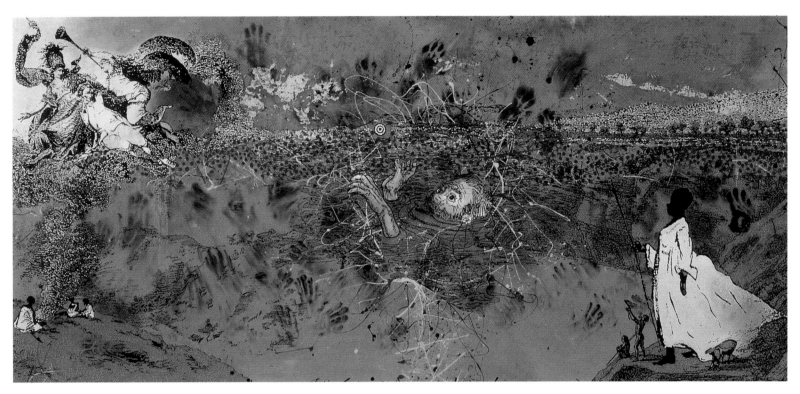

Plate 13
1993
Big Romantic Painting
(Apotheosis of Captain Cook)
182 x 400 cm
Acrylic on canvas
Collection: University of Melbourne
Photo: Kenneth Pleban

splendid era whose existence rehabilitates us both in regard to ourselves and in regard to others.[18]

While I do not wish to underestimate the importance of such an essentialist identity for many people, I soon realised that everything I knew about Aborigines, everything I was finding out about my heritage in my Art College elective on Aboriginal Art and Culture, was filtered through a European perspective, through the canons of Anthropology and Ethnography: those 'men of science' who peered at Aboriginal people and made judgements based on an assumed cultural superiority predicated on such binary definitions as civilised and savage, self and other. Euro-Australian power, knowledge and Aborigines, are mutually constitutive — they produce and maintain one another through discursive practices which have become known as 'Aboriginalism'.[19]

'Aboriginalism' has been characterised by an overarching relationship of power between coloniser and colonised. This renders Aborigines as inert objects who have been spoken for by others. Furthermore, Aboriginalism essentialises its object of study: Aborigines are manufactured in ontological or foundational terms as an essence which exists in binary opposition to non-Aborigines, and which is not subject to historical change.[20] The so called 'mixed bloods' or 'detribalised remnants' have been considered unworthy of serious anthropological consideration since (they) lacked the prestige attached to the classic field-work enterprise which typically involved living intimately for one or two years with people who are isolated from the modern

Plate 14
1993
*Panorama: Cascade (with
Floating Point of Identification)*
137 x 167 cm
Acrylic on linen
Collection: Private
Photo: Vesna Kovac

world.[21] The traditionalist studies of Anthropology and Ethnography have thus tended to reinforce popular romantic beliefs of an 'authentic' Aboriginality associated with the 'Dreaming' and images of 'primitive' desert people, thereby supporting the popular judgement that only remote 'full-bloods' are real Aborigines.[22]

Aborigines are thus still being cast and recast as the living embodiment of the 'childhood of humanity', that which is the evidence of the 'progress' of history and of Western culture. Today popular Primitivism enforces an expectation for contemporary Aboriginal subjects to display or demonstrate evidence of their authenticity, either by asserting an essentialist position (I am Aboriginal), or by being knowledgeable (I know everything about the kinship systems of Arnhemland), as if Aboriginal culture were some kind of endowment.[23] Furthermore, such expectations are based on a myth of an Aboriginal culture that is both static and homogeneous, which is none other than the reified binary 'Other' of the hidden 'norm' that is white and Western.

Aboriginality is no life raft for me. It remains too problematical to identify with and leave unquestioned. After all, it was this very same problem of identification that drove me to bail out of my previous life in the first place, and I wasn't about to provide a foil for anyone to affirm that colonial identity I myself had rejected. I decided that I was in a very interesting position: My

mind and body had been effectively colonised by Western culture, and yet my Aboriginality, which had been historically, socially and personally repressed, was still part of me and I was obtaining the tools and the language to explore it on my own terms. In a conceptual sense I was liberated from the binary prison of self and other; the wall had disintegrated but where was I? In a real sense I was still living in the suburbs, and in a world where there were very real demands to be either one thing or the other. There was still no space for me to simply 'be'.

I decided that I would attempt to create a space by adopting a strategy of intervention and disturbance in the field of representation through my art. I was acutely aware of racist stereotypes and the power/knowledge relationship that governed the historical representation of Aborigines within contemporary Australian culture. Cultural identities are the points of identification, or suture, which are made within the discourses of history and culture — not an essence, but a positioning.[24] Identities come from somewhere, have histories, and like everything which is historical, they undergo constant transformation. Far from being eternally fixed in some essentialised past, they are subject to the continuous 'play' of history, culture and power. Far from being grounded in a mere 'recovery' of the past, which is waiting to be found, and which, when found, will secure our sense of ourselves into eternity, identities are the names we give to the different ways we are positioned by, and position ourselves within, the narratives of the past.[25]

At first my painting was characterised by an overt expressionism informed by theory. My first interest in a theoretical basis for my painting came from theories on postmodern deconstruction and strategies of appropriation as well as the 'grotesque'. I quoted in an essay for my Classicism elective in 1988 a passage from *The Critical Idiom: The Grotesque* by Phillip Thompson:

> The characteristic impact of the grotesque, the shock which it causes, may be used to bewilder and disorient the spectator, jeopardise or shatter their conventions by opening up onto vertiginous new perspectives characterised by the destruction of logic and regression to the unconscious — madness, hysteria or nightmare. Thus the spectator may be jolted out of accustomed ways of perceiving the world and confronted by radically different and disturbing perspectives.[26]

I did a painting in early 1988 that depicted a decapitated Aboriginal figure standing over Vincent Van Gogh's bed (Plate 30, p. 79), with red paint streaming skywards to join with the vortex of Vincent's starry night. It was exhibited at the inaugural Adelaide Biennial of Australian Art in 1990. After the exhibition opening I was subjected to a racist verbal attack in a crowded Adelaide restaurant by a woman who stated that she 'could not handle' my painting. At first I was devastated and returned to my hotel, but later I decided that this attack was at least

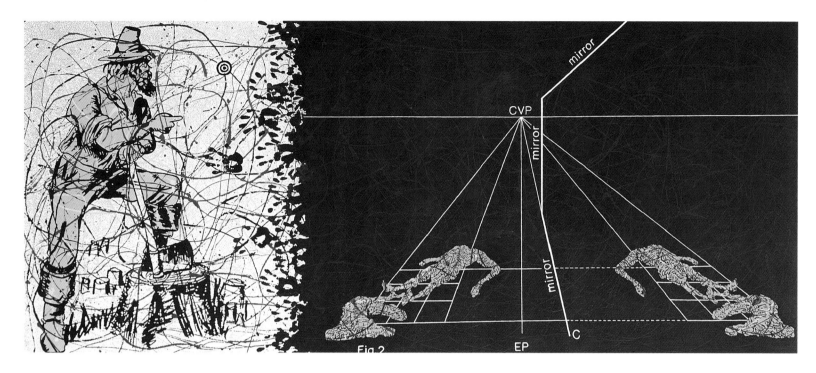

Above: Figure 15
1991
Psychotopographical Landscape
(Arrest). 100 x 100 cm
Oil on canvas
Collection: Private
Photo: Richard Stringer

Top: Plate 15
1993
Terra Nullius (Teaching Aid)
As Far As The Eye Can See
175 x 414 cm
Acrylic on canvas
Collection: Private
Photo: Vesna Kovac

evidence that a painting can have an effect. However, by this time I had already moved towards a 'cooler', more overtly conceptual approach, though which retained elements of the grotesque as a strategy of 'Turning Around'.[27]

In the Aboriginal Art and Culture elective at Art College I also learnt something of the hidden history of colonial Australia, of the outrageous violence perpetrated in the name of 'civilisation'. Through the reading lists I discovered such historians as Henry Reynolds who, far from being the kind of historian described previously in the 1917 school history primer, was interested in addressing the imbalance of Australian history by describing life on the other side of the frontier.[28] Reynolds also acknowledges the major contribution made by Aboriginal people in the exploration and development of Australia, information that was new to me.[29] For me this kind of information served to strengthen my developing critical awareness of a 'politics' of representation. The ways in which black people, and black experiences were positioned and constructed as subjects in the dominant regimes of representation were the effects of a critical exercise of cultural power and normalisation. Aboriginal people were constructed as different and other within the categories of knowledge of 'Western' culture by those regimes. They had the power to make us see and experience ourselves as 'Other'.[30]

In 1988 Australia was in the grip of Bicentennial celebrations that saw various re-enactments of one sort or another, including the 'tall ships' event that saw a group of sailing vessels set out to retrace the journey of the 'first (European) fleet' to Australia. Aboriginal groups declared a year of mourning. I began to use illustrations out of old social studies and history

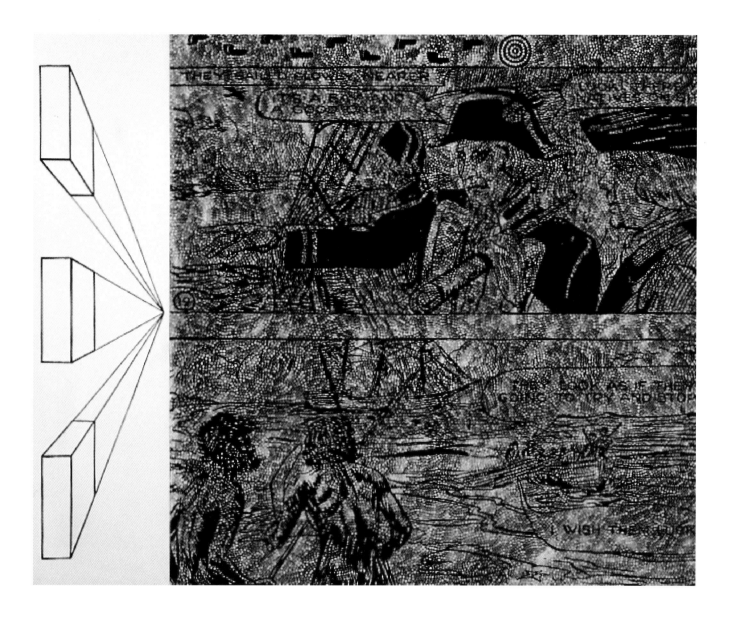

Above: Figure 15
1988
Prologue: They Sailed Slowly Nearer
118 x 198 cm
Oil on canvas.
Collection: Museum of Modern Art,
Heide (Baillieu Myer)
Photo: John Brash

textbooks by way of critical intervention in the seamless flow of images that I plainly saw was designed to reinforce the popular myths and 'common sense' perspective of an Australian colonial identity and 'pop' history. I had in mind to create fields of disturbance which would necessitate re-reading the image, and the mythology. For example I foregrounded perspective because its discursive underpinning of the colonialist field of representation exposed the ideological framing of the observing subject and the observed 'object' within a Eurocentric power structure. By disrupting this field of representation, I hoped to implicate the observing subject in the production of meaning, not in order to affirm the subject but in order to stimulate thought, and the possibility of exceeding the historical parameters that frame it.

As the foundation of a system of representation, perspective produces an illusion of depth on an essentially flat two dimensional surface by the use of invisible lines that converge to a vanishing point. The vanishing point may also be understood as the point from which these

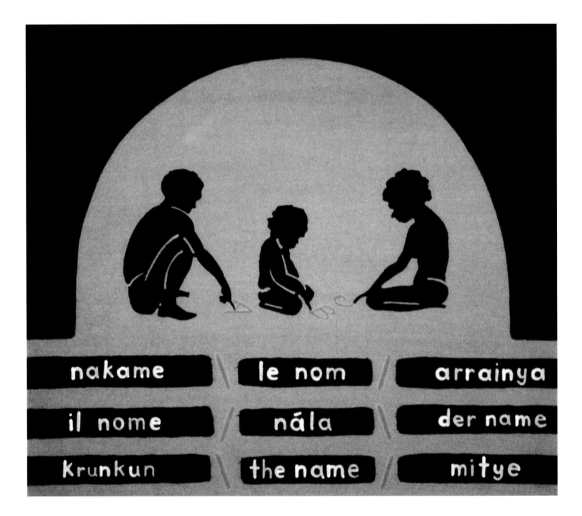

Figure 17
1992
Relative/Absolute (The Name)
46 x 55 cm
Acrylic and flashe on canvas
Collection: The Artist
Photo: Gordon Bennett

lines extend outward past the picture plane to include the viewer in the pictorial space, positioned as observer of a self-contained harmonious whole. Perspective has been called: 'a systematic abstraction from the structure of (. . .) psychophysiological space'.[31] In its positioning of the viewer and in relation to the horizon line, perspective may be seen as symbolic of a certain kind of power structure relating to a particular European world view. The viewer is placed in a position of centrality to an ordered array of phenomenon which is rendered completely visible in a compressed symbolic configuration; particular inflections of knowledge are indexed allowing comparison, distinction, contrast and variation to be instantly legible.[32] It is an ideological fabrication, a powerful format of representation fixing relationships by which individuals represent themselves in their world of objects, their signifying universe, both a mirror of the world and a mirror of the self.[33] Aborigines caught in this system of representation remain 'frozen' as objects within the mapped territory of a European perceptual grid.

The *Collins English Dictionary* defines perception as: 'to thoroughly grasp or comprehend; to recognise a thing through the senses especially the sense of sight'. To me this begs the question of how do we *recognise* what we perceive? Recognition presupposes having already seen a thing,

atwa / l'homme
l'uomo / malie
naroa-mine / the man

la femme / lubra
nongo / la donna
the woman / toora

Above: Figure 18
1991
Relative/Absolute (Man + Woman)
116 x 195.5 cm
Acrylic and flashe on canvas and wood
Collection: The Artist
Photo: Gordon Bennett

it implies previous knowledge of the thing being observed, or at least an already given knowledge from which to base your observation. Knowledge is something we are taught, and also gain by experience during our lifetime. Knowledge is learnt experience and to be learnt it needs a vehicle for its transmission and indeed for its very structure. This vehicle is language.

Language is something we are all very familiar with, in fact at times it is a faculty that is so taken for granted that it seems an entirely natural phenomenon intimately and directly related to the world in which we live. In fact it becomes all too easy to make the safe and simple assumption that language is a natural inventory of the world of experience.[34] However it is not, it is never natural, as anyone who can remember the childhood experience of learning the alphabet, spelling and the structure of sentences can attest. As children we become socialised into a particular societal structure, a network of relationships to, and ideas about, the world that is constructed by language. Indeed, language may be seen as the cement that binds and maintains the social organisation of a particular society or cultural group.

Language defines the invisible boundaries or limits to the understanding of the world of

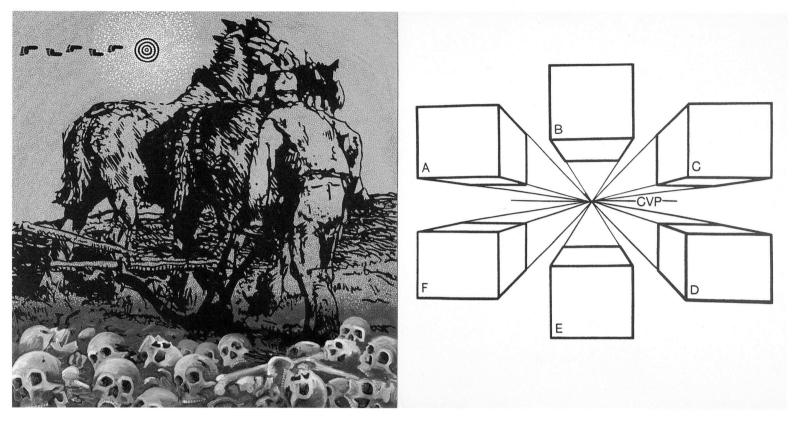

Plate 16
1988
The Plough
130 x 260 cm
Oil and acrylic on canvas
Collection: Private
Photo: Richard Stringer

experience. It does not constitute a natural inventory of the world, but rather language is a system of conventional and arbitrary sounds and symbols that represents the culturally relative subjective human *perception* of it. Thus a word does not represent an object in itself, it represents the image of the object reflected in the human mind.[35] I am interested in this conceptual gap or 'space' between language as a representational signifying sign system, and the world of objects and sensation this system signifies or refers to.

In 'representational' painting a painter uses paint in a particular way. The paint is organised into areas of colour, areas of light and dark tones, areas of varying shapes and size in order to create a painting that is a reflection of the artist's perception of the landscape. In fact the artist draws on a set of conventional visual signs and devices to represent an essentially subjective human perception of the world. The image produced does not represent the world itself but represents the image of the world as reflected and organised by the artist's mind. Thus a visual sign or *icon* may be understood as separated from the world of things by the same conceptual space as language. The system of visual signs that constitutes the iconography of a Western art tradition of representation can therefore be determined as functioning in a similar way to a language in its structuring of a visual world view.

Implicit in the term 'world view', it should be noted, is the notion of *ideology*. Ideology, when understood as a body of ideas about the world that reflects the beliefs and interests of a

Figure 19
1989
Australian Icon (Notes on Perception No 1)
76 x 57 cm
Oil and acrylic on paper
Collection: Private
Photo: Gordon Bennett

cultural group or society, is reflected, maintained and reinforced by visual representation. Representation is in fact a powerful social instrument for the creation and maintenance of the world in which we live.[36] This applies equally to Australian Aboriginal societies as it does to any Western society, indeed it applies to all societies.

Soon after graduating from Art College in 1988 I painted a series of works which I called:

Figure 20
1989
Australian Icon
(Notes on Perception No 6)
66 x 56 cm
Acrylic on paper
Collection: Private
Photo: Gordon Bennett

Australian Icon: Notes on Perception. I began by selecting a detail, or reduced section, of a reproduced historical image, specifically a painting of Captain James Cook. I photocopied the selected part, enlarging it and then projecting it onto a piece of paper. I saw this as a kind of ritual practice that in a sense replicated or even parodied the selective process of a teleological historical perspective. I painted the image in the quick gestural brush strokes of what may be termed a Western art tradition. I then inserted dots in the spaces between the brush strokes, some of which were created by the photocopy enlargement process, in what may be referred to as an Aboriginal art

tradition. I combined Cook with an image of an Aborigine's head in classical 'noble savage' pose with face uplifted (taken from a beer coaster), and enclosed it in a box-like structure created by perspective lines that converged to a vanishing point in the centre of Cook's eye.

The resultant image I related to as a kind of 'mapping' of two of the major icons of my cultural socialisation. I called the work *Australian Icon (Notes on Perception No 1)*. I continued the series with images and details of nineteenth century photographic postcards that staged Aboriginal people in supposedly 'natural' environments. By re-contextualising these images I gave them new meaning by placing them in another time and place and in new relationships to the present with its different sense of world view and the benefit of a critical distance to the time in which they were produced. I called these works *Australian Aborigines (Notes on Perception)* and assigned each its own number. These works relate to the 'evolution' of an Aboriginal stereotype, i.e. what a 'real' Aborigine looks like. Everyone could, and still can no doubt, 'picture' an Aborigine in their mind's eye and this picture has become the internalised icon against which contemporary Aborigines are measured.

The method of gestural brush strokes and dots in the works on paper combine at close range to obscure the image. The image is dissolved in brush strokes and dots until one steps back a short distance from the surface to find the image 'reveals' itself. This is important in that it is essentially one's mind that constructs the image out of the mass of data which is paint on a surface perceived by the organ of sight. What the mind constructs is based on the past learnt experience of cultural conditioning and culturally relative knowledge.

Australian Icon (Notes on Perception No 6) is a detail from a larger work depicting a ship in a storm. Which particular ship is unimportant. It is its '*shipness*' that is important. Up close to the image it is difficult to determine anything except paint on a surface. At a distance the ship will appear as the mind recognises and constructs it. The observer sees a sailing ship because of the mind's perception of 'shipness', i.e. the image resembles what a sailing ship is supposed to look like based on previous experience of sailing ships, or images of them. What the image of a ship means to the observer is relative to that person's cultural associations as to their purpose and historical context, etc. In relation to Australian history, and particularly so soon after the Bi-centennial as it was painted in 1989, a ship is very likely to be interpreted in relation to the 'first (European) fleet', or even Captain Cook's 'Endeavour'. I chose an image of a ship specifically to evoke the romantic narratives of adventure, danger, exploration and discovery that form a major part of the mythology that informs an Australian 'mainstream' identity. Of course it could just as easily have been interpreted as a slave ship, but is not as likely to have been interpreted in that way given its Australian context — even though many

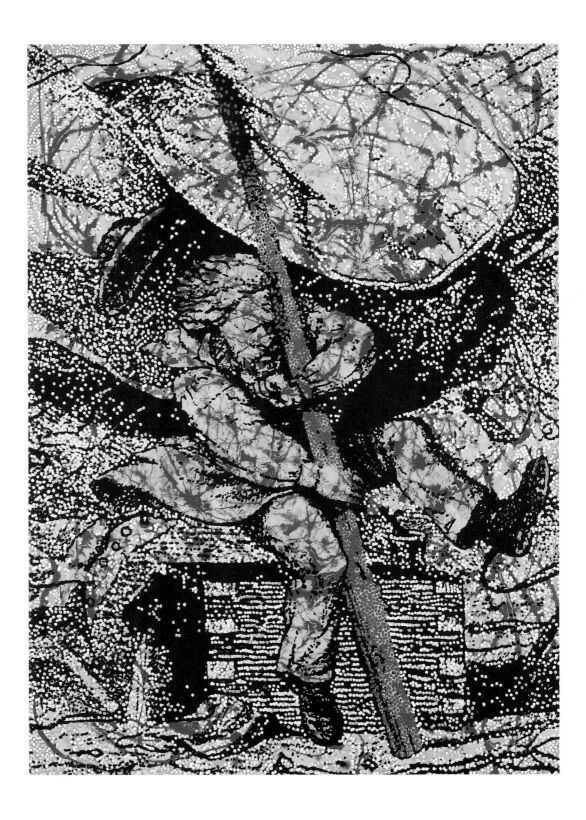

Plate 17
1991
Explorer
168 x 125 cm
Oil and acrylic on canvas
Collection: Private
Photo: Richard Stringer

of the convict ships that made the journey to Australia were in fact ex-slave ships.

It has been said of Aboriginal art of the Western desert that it produces a finite design by subtraction — even quotation — from a potentially infinite grid of connected places/'Dreamings'/people, in which real spatial relationships are literally rectified and represented.[37] My approach to 'quotation' within the 'mainstream' European tradition is to select

images from Euro-Australian art history, that have accumulated certain meanings over time, placing them in new relationships to other images. The images I select exist between the pages of art books and history books. Their unifying factor is the dot screen of their photo-mechanical reproduction and their iconographical relationships as points of reference, or 'sites', on a Western cultural perceptual grid. By recontextualising images subtracted from this grid of Euro-Australian 'self' representation I attempt to show the constructed nature of history and of identification as arbitrary, not fixed or natural, but open to new possibilities of meaning and of identification.

In a sense then, this strategy has its parallels in the art of Aboriginal people from the Western desert in firstly its subtraction, quotation from a potentially infinite grid of points or 'sites' of identification; and secondly in its exposure of the fact that images, as iconographical sites of reference, can have different meanings in different contexts. It has been established elsewhere that Western desert artists employ a basic set of iconographical symbols such as curved and straight lines, concentric circles and dots which all have multiple meanings depending on their contexts.[38]

My use of dots, apart from their aesthetic potential, is in one aspect a reference to the unifying dot matrix of photographic reproduction and in another sense it is Aboriginal referential in the dots relationship to the unifying space between cultural sites of identification in a landscape that is not experienced as separate from the individual, but as an *artefact of intellect*. In traditional Aboriginal thought there is no nature without culture, just as there is no contrast either of a domesticated landscape with wilderness, or of an interior scene with an expansive 'outside' beyond four walls.[39] This notion led me to conceive of the eurocentric perceptual grid, with its sites of iconographical signification, as a landscape of the mind — a 'psychotopographical'[40] map where sites, located in memory, represent the subjective human identification with the perceptual world.

I use postmodern strategies of quotation and appropriation to produce what I have called, as an ironic strategy, 'history' paintings. I draw on the iconographical paradigm of Australian, and by extension European, art in a way that could constitute a kind of 'ethnographic' investigation of a Euro-Australian system of representation in general, but which has focused on the representation of Aboriginal people in particular. By recontextualising images, or fragments of images, in particular relationships I hope to create a turbulence in the complacent sense of identification with pop history, and create a kind of chaos of identification where new possibilities for signification in representation can arise; in this way new relationships to others may be forged by the insights gained from the understanding and perception of 'flux' and 'nuance' that exist between any hard-and-fast definitions of identification.

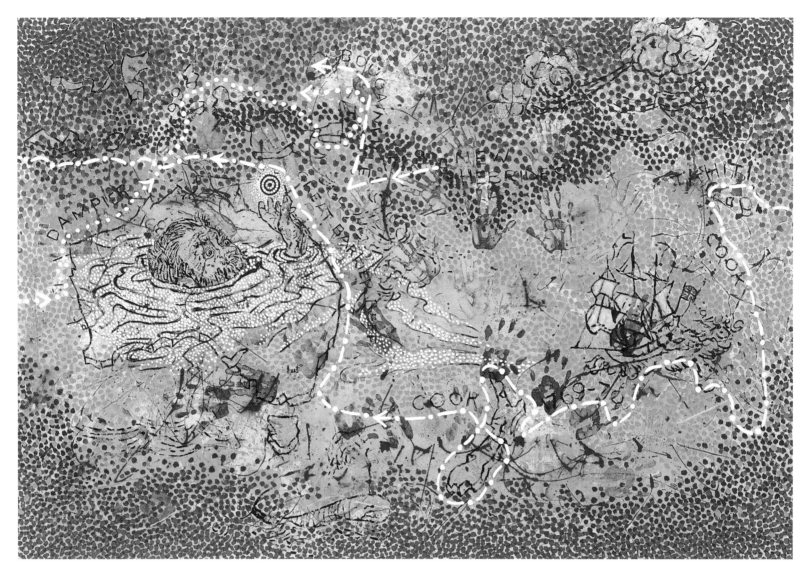

Plate 18
1993
Haptic Painting (Explorer: The Inland Sea)
177 x 265 cm
Acrylic on canvas
Collection: Private
Photo: Richard Stringer

In 1990 I began referring to Jackson Pollock's work extensively by making paintings using a pastiche of his signature dripped paint style and then 'floating' images within the painted field where they could be brought into differing relationships. I was interested in the way in which people often imagined that figures were lurking in Pollock's 'abstract' fields. It seemed to me to be like 'cloud gazing' where a person may perceive recognisable shapes within the shifting formations of clouds. It felt to me to be an obvious extension of the *Notes on Perception* series. I also regarded that the implied extension of Pollock's matrix out past the frame and field of representation was important in referring to my selections of images as 'sites' on a potentially infinite grid.

In 1991 Thomas McEvilley seemed to confirm my intuitive approach to Pollock's painted field by interpreting Pollock's drip painting as:

. . . assert(ing) flux and indefiniteness of identity as qualities that can be found in the

world. This tautological interface between form and content is not a mystical attempt to unify opposites. It simply means that a work demonstrates a type of reality by embodying it. Thus abstract art, far from being non-representational, is, in effect, a representation of concepts; it is based on a process like that of metaphor, and overlaps somewhat with both iconography and representation.[41]

I thought of Pollock's position as one of the last Modernist 'heroes'. I was also interested in how art history, the narratives of North American colonialism, and the notion of 'primitivism' had positioned him in the establishment of an 'American style' of art by tracing his development to his birth in the American west and his interest in Navaho ground painting. This is a story that has been played out many times and is equally relevant to Australia. Quite apart from Pollock's probable genuine interest in Navaho ground painting, we have the myth of the sophisticated and civilised 'white' artist who discovers something of value in the art of 'primitive' indigenes and brings it back to enrich the lives and cultivated sensibilities of 'real' artists and 'ART'. Meanwhile, the poor natives fall from grace, their primitivist purity — circumscribed by the recurrent belief that the qualities of 'primitive' or chronologically early cultures are superior to those of contemporary civilisation[42] — are hopelessly contaminated by contact with 'civilisation', they descend to the level of producing 'quaint' folk art, craft or 'airport' art produced only for commercial gain with inauthentic materials and motives.

I can't say how often I've heard that banal argument, let alone defended myself against it, and other institutionalised racist platitudes and misapprehensions. Institutionalised racism has been described as a racism practised and controlled by an institution or society; it includes actions controlled by the norms, rules, or customs of an institution or society.[43] The West, it seems, is the self declared leader of history, guiding the peoples of the world towards an Hegelian sunset. Voyages of plunder and conquest were recorded as 'voyages of discovery', undertaken, supposedly, as altruistic attempts to lead other peoples toward history's culminating spiritual realisation. My life experience, and that of my mother, has led me utterly to reject this idea of progress and I can only agree with Thomas McEvilley when he suggests that: '. . . at the heart of Modernism was a myth of history designed to justify colonialism.'[44]

The Modernist period was dominated by the seventeenth-century German idealist philosopher Georg Wilhelm Friedrich Hegel. Hegel's belief was that history had an internal direction and goal, and that 'progress' was, in effect, a law of nature. Entranced by this faith the western nations felt that history was on their side, that it was taking them where they wanted to go — to the vaguely conceived spiritual culmination which Hegel had written about. History was more like Providence, really, benignly watching over and guiding.[45] The formation of the idea of

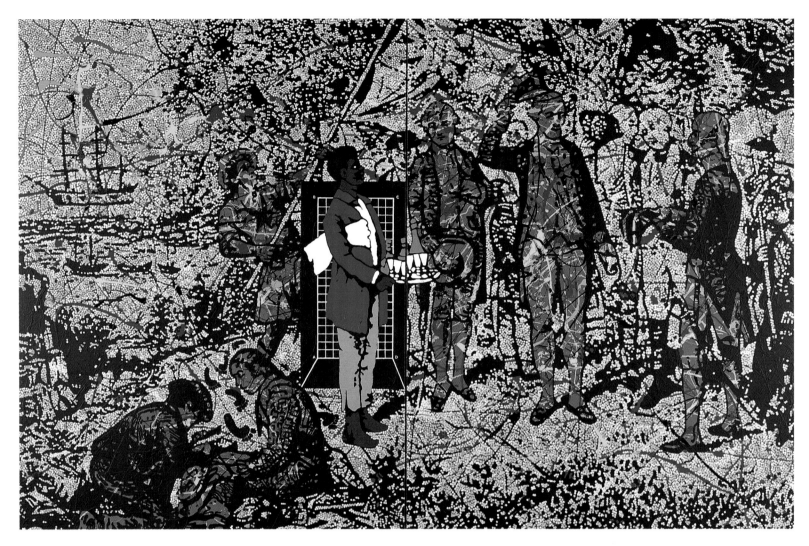

Plate 19
1991
Possession Island
162 x 260 cm
Oil and acrylic on canvas
Collection: Private
Photo: Xavier Lavictorie

progress in art in terms of the spiritual advancement of humanity was the fuel of the transcendental Modernist stream that ran through the works of Kasimir Malevich, Wassily Kandinsky, Piet Mondrian, Yves Klein, Lucio Fontana, Mark Rothko, Barnett Newman and many others.[46]

As it has been developed by historians, at least in the post-Enlightenment period, history has a linear sense of time and records the past of 'civilised' literate peoples and their 'progress' towards the present. In the nineteenth century and much of the twentieth century this historiography was an important means of teaching people to know themselves as citizens of bourgeois society and the nation-state. In this conception of the discipline, 'illiterate', 'savage' Aborigines had no history, just as they had no future place in the Australian nation founded in 1901: they were a dying race doomed to disappear. Thus history in Australia began not with Aborigines but with the arrival of the Europeans.[47]

When Captain James Cook first set eyes on Australian shores, he carried with him his cultural baggage that positioned him and his culture at a point along the teleological perspective

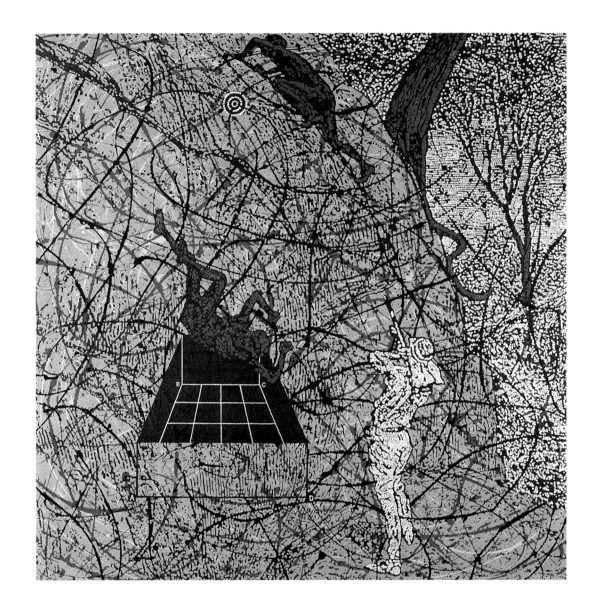

Plate 20
1993
Death of the Ahistorical Subject (Vertigo)
182 x 182 cm
Acrylic on linen
Collection: Private
Photo: Richard Stringer

lines of history. It was just a matter of *recognition* to position Aborigines as 'primitives', 'savages' and therefore as 'ahistorical'. However, such beliefs have been proven to be nothing more than the distorted mirror reflection of European societies. The history of the theories of 'primitive' societies is the history of an illusion, as much an illusion as the construction of three-dimensional space on a two-dimensional surface.

The theory of 'primitive' society is about something which does not and never has existed. Hardly any anthropologist today would accept that a 'classic' account of 'primitive' societies can be sustained. On the contrary, the orthodox view is that there never was such a thing as 'primitive society'. Certainly, no such thing can be reconstructed now. There is not even a sensible way in which one can specify what a 'primitive society' is. The term implies some historical point of reference. It presumably defines a type of society ancestral to more advanced forms, on the analogy of an evolutionary history of some natural species. But human societies

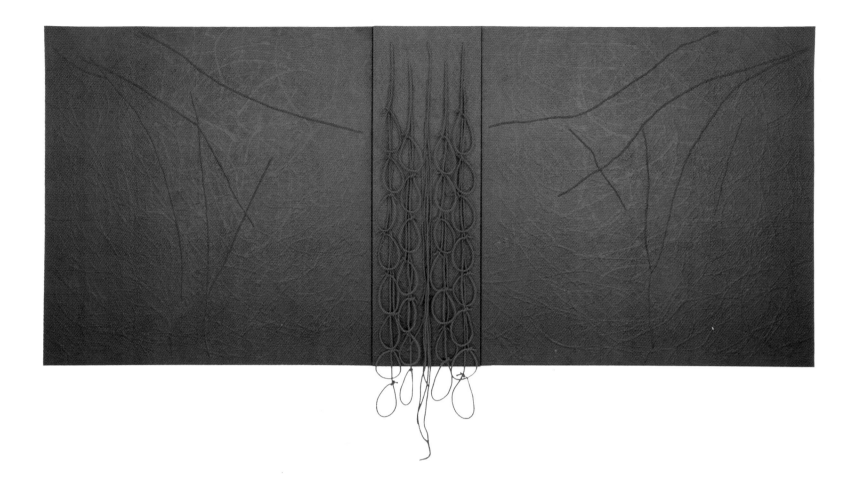

Plate 21
1993
Bloodlines
182 x 425 cm
Acrylic on linen, wood and rope
Courtesy Bellas and Sutton Galleries
Photo: Richard Stringer

cannot be traced back to a single point of origin, and there is no way of reconstituting prehistoric social forms, classifying them, and aligning them in a time series. There are no fossils of social organisation.[48]

In the 'welt' series of paintings, which I began in France in December 1991, I overpainted a Pollock drip style underpainting with black. This created a surface which looked remarkably like an illustration of the scarified back of an African slave I later saw reproduced in a book about the representation of Blacks in the nineteenth century; the title of the triptych was *A Typical Negro, 1863*.[49] I drew on the conventional European cultural associations of 'blackness' which positioned the colour itself as representing the polarised qualities of life in the binary equations white/black, light/dark, civilised/savage, self/other, etc.

In these works I also made reference to Malevich's abstract, or non-objective, 'Black Square' and 'Cross' formations, and Lucio Fontana's cut canvases. The term 'abstract' usually means to generalise, or to universalise, attributes that may be seen as common to one and all. It is usually seen as being opposite to the representation of a specific thing as opposed to the representation of an 'essence' that is rather common to many things. Thus representation and abstraction are usually seen as opposites. My concept and use of abstraction in these works is

Plate 22
1994
Wound
92 x 65 cm
Acrylic and flashe on canvas
Collection: The Artist
Photo: Richard Stringer

closer to the spirit of McEvilley in the representation of concepts so that 'a work demonstrates a

type of reality by embodying it'.

Malevich's black square may be seen as a representation of the concept of the human

spirit. Being Russian, his abstract works are sometimes related to as icons in a similar vein to the great religious icons of Byzantium. However, Malevich was most certainly trying to get beyond the medieval denominational religious confines of such icons to a kind of spiritual 'essence' that was common to all humanity. I certainly have no quarrel with that, and I admire Malevich very much, but it is clear that in reality black and indigenous peoples, as people considered ahistorical — trampled, enslaved, exploited and discarded, their lands confiscated and wealth plundered over five hundred years of colonialism — were not to be joining Europeans on their great journey to that glorious sunset and spiritual culmination waiting for humanity just over the horizon line.

My intention was to imbue such commendable spiritual aspirations with a little physical realism. With the 'welt' pieces I wanted to convey the wounding of the human spirit, its scarification; the overpainted Modernist trace of a Pollock skein as metaphor for the scar as trace, and memory, of the colonial lash. On some of the works in the series I used text created by laying down beads of red paint, overpainting in black and then cutting into the raised bead to reveal its red interior. The texts so created were metaphors for the inscription of the black body as '*Tabula Rasa*', as the darkness which is 'illuminated' by 'the coming of the light'; the so-called civilising force of European colonialism that created, cast and inscribed the objectified black body and mind as its 'Other'. It is generally acknowledged that, at least since the Enlightenment, the category of the 'self', and the group, is fashioned through the construction of an Other, which is outside and opposite, and that the making of an identity rests upon negating, repressing, or excluding things antithetical to it.[50]

It may be argued that in taking this position I am portraying black people as victims. This was indeed my intention and I wanted to not only 'play the victim' but to take it further and use that energy to advantage by not resisting, or trying to display strength, but to show pain and how much it hurts, even to the extent of self-mutilation. In this I am drawing on Aboriginal funeral ceremonies in which ritualised public displays of grief and mourning can involve blood-letting and cutting one's own body. Lucio Fontana's cut canvases and the ceremonial scarification of initiation rights common to both Aboriginal, and some African peoples, were both factors in making these works. My interest in Taoism is also significant in the sense of utilising a strategy of least resistance, which uses an aggressor's energy by turning it to one's own advantage, rather than opposing a force directly, better to intercept obliquely, or roll with it turning the opposing energy around for your own advantage.

The 'grotesque' remains as a theoretical subtext in these and other works that show decapitated and otherwise mutilated Aboriginal bodies 'polluting' the otherwise serene quality

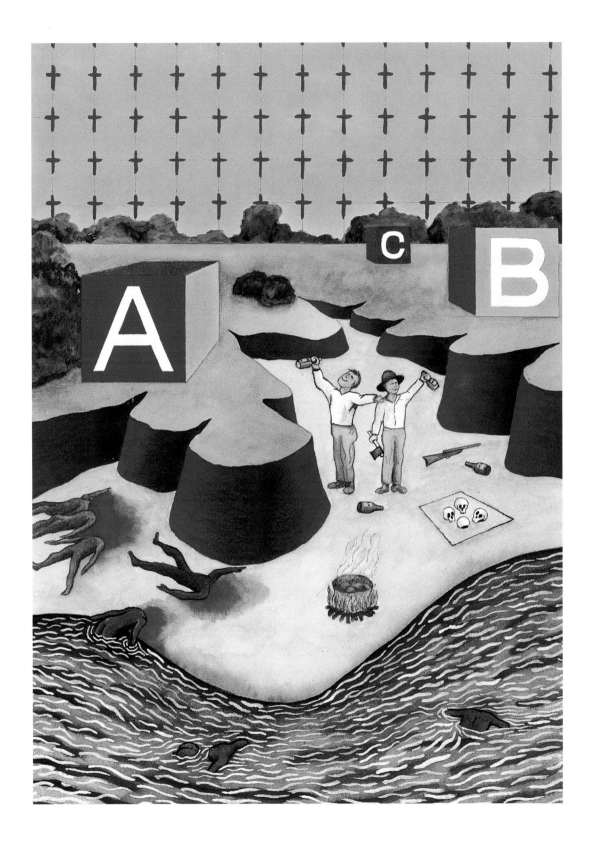

Plate 23
1991
Bounty Hunters
37 x 27 cm
Watercolour on paper
Collection: Private
Photo: Phillip Andrews

of colonial images depicting 'peaceful settlement' of the Australian landscape. All these works have their genesis in historical 'fact' in that they respond to actual recorded events or appropriate already existing imagery. My strategy in depicting 'victims' was partly a subversive one and partly acceptance of actual events and my own experience. While it is true that Aboriginal

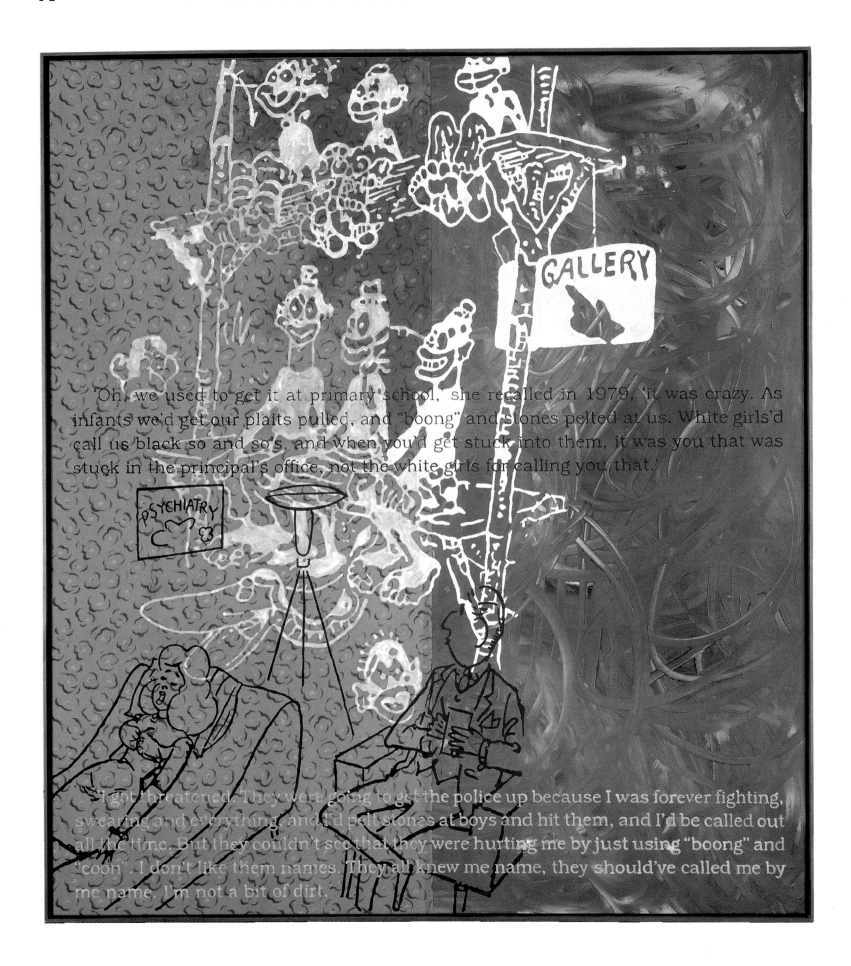

'Oh, we used to get it at primary school,' she recalled in 1979, 'it was crazy. As infants we'd get our plaits pulled, and "boong" and stones pelted at us. White girls'd call us black so and so's, and when you'd get stuck into them, it was you that was stuck in the principal's office, not the white girls for calling you that.'

'I got threatened. They were going to get the police up because I was forever fighting, swearing and everything, and I'd pelt stones at boys and hit them, and I'd be called out all the time. But they couldn't see that they were hurting me by just using "boong" and "coon". I don't like them names. They all knew me name, they should've called me by me name. I'm not a bit of dirt.'

people did fight long and hard for their land — indeed the fight is still being played out through the courts — I was always more interested in questioning the field of representation, and the cultural conceits it embodied, rather than creating Aboriginal 'heroes' of the resistance, and there are many resistance fighters to choose from to challenge the white myths of 'peaceful settlement'. I abhor violence, and I have little compulsion to glorify it in any case, so I thought of the depiction of violence as a way to disturb firstly the complacent acceptance of Australia's sanitised history, and secondly, through the shock of that disturbance, to 'jolt' the spectator 'out of accustomed ways of perceiving the world' and perhaps foster empathy and understanding of contemporary issues that affect all of us as human beings.

Epilogue

Like many artists during their lifetime I feel my motives have been misunderstood. I'm not one for saying what art should or should not be, but I do believe art can function to expand one's consciousness, to act as a catalyst perhaps, to exceed the boundaries of language and how it defines and limits our understanding of the world in which we live. However, my work has been met with accusations of 'moralising' and of being 'heavy handed' which I find quite disturbing, particularly given that I am quite often only recirculating already existing images. The implication in such criticisms seems to be that these images should stay buried, that perhaps some people, with misplaced feelings of guilt, rather than recognising the obvious alternatives of empathy, compassion and understanding, feel that they cannot 'handle' my paintings, or is it their own feelings, or the truth of a nation born out of near genocide, they cannot handle?

Many people want to dismiss the past in regard to an Aboriginal experience, as if it bears no relationship to the present, or for that matter to the future — but of course they see it differently when applauding 'our pioneer spirit'. They naively say we should forget the past and get on with the future. My only response to that is 'lest we forget'. Why should we forget the experience of peoples who fought for their country and way of life against overwhelming odds, people who are still fighting, indeed fighting for something as basic as human dignity? In a country that reveres the 'fallen warrior' in monuments right across the land, why should it be

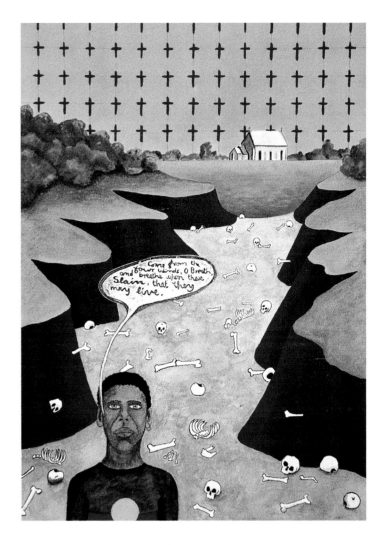

Plate 25
1991
Valley of Dry Bones
37 x 27 cm
Watercolour on paper
Collection: Private
Photo: Phillip Andrews

Opposite: Plate 24
1995
I'm Not Dirt (Empathy)
167 x 152.5 cm
Acrylic on canvas
Collection: Parliament House, Canberra
Photo: Courtesy Parliament House, Canberra

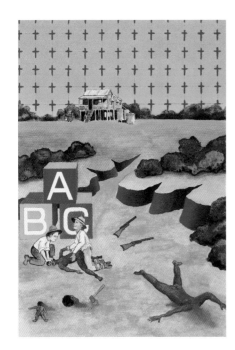

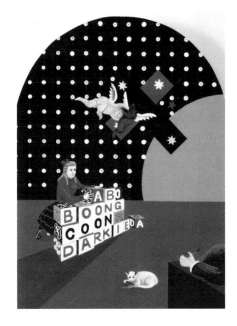

Above: Figure 22
1994
Daddy's Little Girl 2
40 x 30 cm
Acrylic on wood
Collection: Private
Photo: Gordon Bennett

Top: Plate 26
1991
The Small Brown House
37 x 27 cm
Watercolour on paper
Collection: Private
Photo: Phillip Andrews

that Australians who bled on their own soil be excluded? In a country that celebrates its past with a national public holiday, why is it that for Aboriginal Australians the past should be forgotten?

I believe it is important for all Australians that an Aboriginal historical experience be recognised as an integral part of Australian history. For every statement regarding a 'pioneer spirit' there is an equal Aboriginal spirit of stoicism in the face of overwhelming adversity, for every 'explorer's' journey of so-called discovery there was an Aboriginal excursion into an alien world. The historian Henry Reynolds has written:

> In the long run black Australians will be our equals or our enemies. Unless they can identify with new and radical interpretations of our history they will seek sustenance in the anti-colonial traditions of the third world. If they are unable to find a place of honour in the white man's story of the past their loyalties will increasingly dwell with the 'wretched of the earth'. But if the Aboriginal experience is to be woven into new interpretations of Australian history changes will be necessary. We will have to deal with the blacks as equals or they will see our sudden interest in their history as merely another phase of our intellectual usurpation of their culture and traditions. We must give due weight to the Aboriginal perceptions of ourselves and they will not be flattering.[51]

Many people, it seems, have come to regard any expression of an Aboriginal point of view or experience as some kind of 'guilt trip' designed to make non-Aboriginal people feel bad about Australia's past. In fact some politicians dismiss such expressions as part of a 'guilt industry'. I feel saddened, and not a little disgusted, that these people expect Aboriginal people to keep quiet about our history, quiet about our experiences. And to those who dare break the 'white blanket' of silence are directed the emotional accusations of 'moralising', as if morality is a dirty word and has no place in art. The history of Western art and its relationship to the church and so-called 'high culture' should indicate, to even the most ignorant, that morality has always been a driving force in art; particularly in colonial art, and it is even more evident in the representation of Aboriginal peoples.

Certainly, 'white' Australia has proven itself to be a master of moralising; my own experience confirms that much. It seems that any expression of an 'Aboriginal' perspective, or critique of colonial narratives and myths — both romantic and 'scientific' — is derided by some people as 'the guilt industry'. Alternative views are also dismissed by labelling them in a derogatory manner as 'politically correct'[52] — even to the extent of the Queensland Government, in 1993, pulping year five primary school readers that dare to deviate, or offer alternatives from the conventional line and myth of 'peaceful settlement'. The shrill cries of such derision always

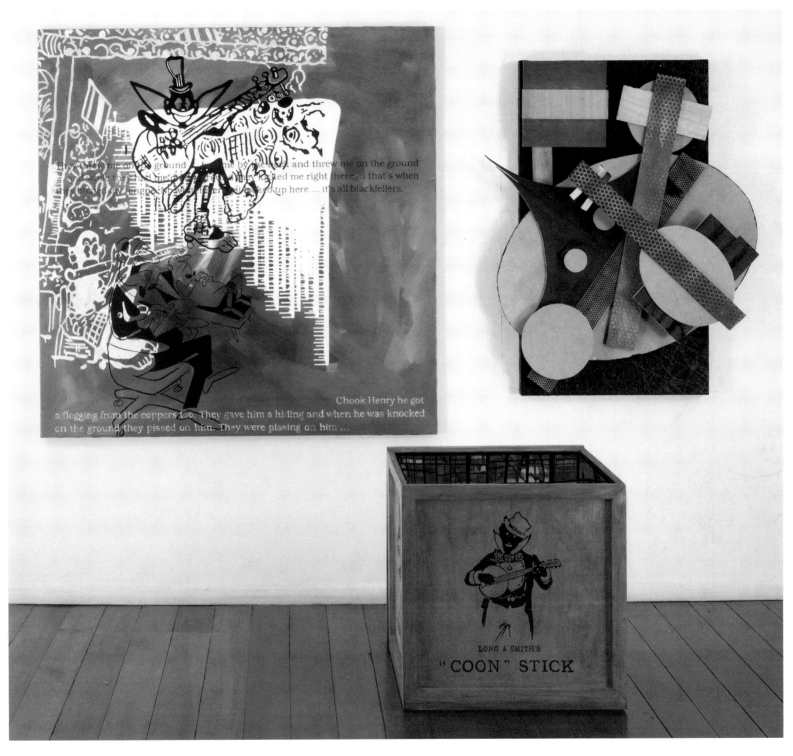

Figure 21
1995
If Banjo Paterson Was Black
Size variable
Mixed media
Collection: Queensland Art Gallery
Photo: Sam Charlton

seem to drown out the real issues, and any form of rational discussion and examination of them. Aboriginal children go to school too. Brave indeed is an Aboriginal child who stands up in class and gives confidently their point of view from a 'place of honour in the white man's story of the past', when the very instruments of their education marginalise, not only their point of view, but their ancestors, and even their own experience. I guess pulping books that dare to tamper with

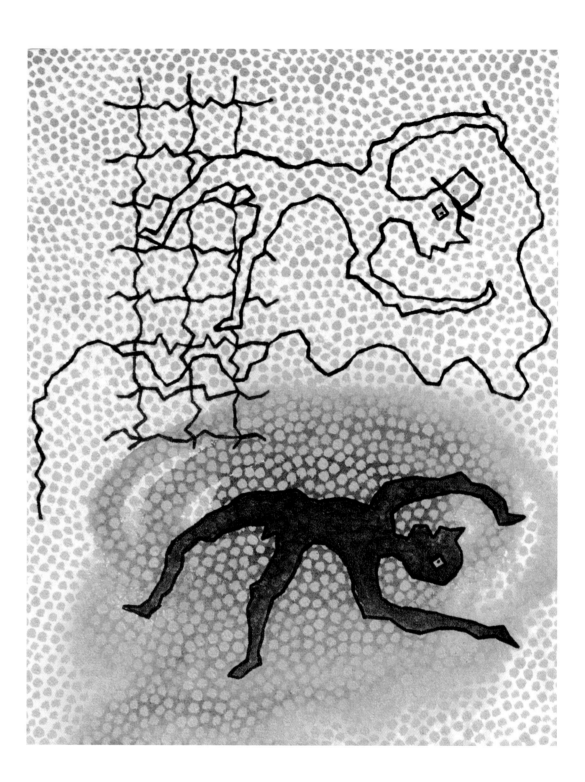

Figure 23
1993
Man with Whip and Shadow
(Stairway to Heaven)
50.5 x 40 cm
Acrylic on canvas
Courtesy Bellas and Sutton Galleries
Photo: Gordon Bennett

'white' myths is far more subtle, and at least more ecologically sound, than burning them?

While I'm sure that such irrational and emotive forms of 'defence' are great for 'white' Australian social cohesion and bonding, it does tend to make a mockery of Australia's moralising to other countries on human rights; not to mention the myths of 'a fair go', and 'free speech'. It is clear that history involves a rearrangement of the past which is subject to the social, ideological, and political structures in which historians live and work. It is also clear that history

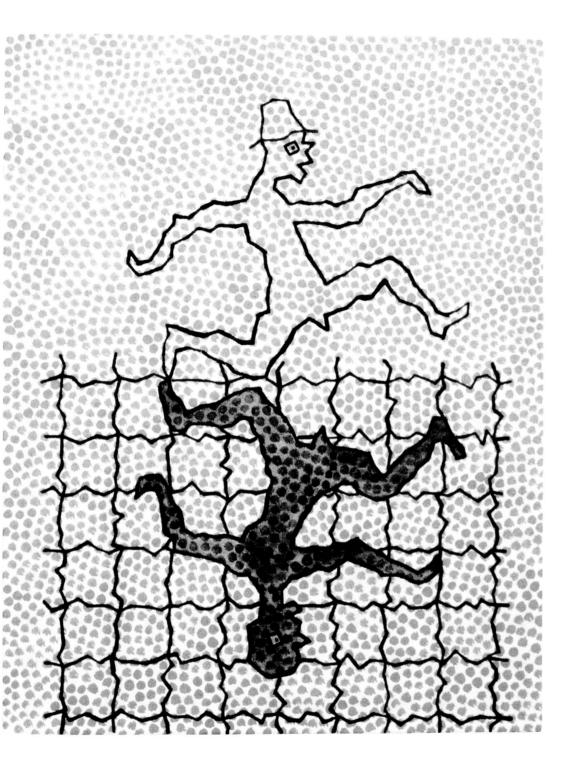

Figure 24
1993
Running Man and Shadow
50.5 x 40 cm
Acrylic on canvas
Courtesy Bellas and Sutton Galleries
Photo: Gordon Bennett

Figure 25
1993
Through the Void (Diving Board)
30 x 20 cm
Soft ground etching on paper
Courtesy Bellas and Sutton Galleries
Photo: Richard Stringer

has been and still is, in some places, subject to the conscious manipulation on the part of political regimes that oppose the truth. Nationalism and prejudices of all kinds have an impact on the way history is written and taught to our children.[53]

I have never started out to do a 'political' painting. If my work is political then that is because of the politics of my position and the cultural climate in which I live and work. I didn't go to art college to graduate as an 'Aboriginal Artist'. I did want to explore 'Aboriginality', however, and it is a subject of my work as much as colonialism and the narratives and language that frame it, and the language that has consistently framed me. Acutely aware of the frame, I graduated as a straight honours student of 'fine art' to find myself positioned and contained by the language of primitivism as an 'Urban Aboriginal Artist'. While some people may argue this has been a quick road to success, and that my work is 'authorised' by my 'Aboriginality', I maintain that I don't have to be an Aborigine to do what I do, and that 'quick success' is not an inherent attribute of an Aboriginal heritage, as history has shown, nor is it that unusual for college graduates who have something relevant to say. Being aware of my positioning I have often used it as a 'strategic logocentre' in response to a society that seeks to transfix me with the patronising and conceited gaze of those who only seem able to think in terms of the conventional and 'common sense' binaries of the 'noble' or 'ignoble' savage.

Thus (sm)othered I embarked on a critique of the foundations of this and other stereotypes of 'Aboriginalism'. I am very aware of the boundaries of critical containment within the parameters of 'Urban Aboriginal Art', and have so far worked within these boundaries to try and broaden, extend, and subvert them. The reality is, however, that I never really had much choice; and I have been faced with my work not entering some collections on the grounds of it being not 'Aboriginal' enough, to being asked to sell my work through stalls at cultural festivals, to being described, along with two other artists, in the catalogue of a recent Australian exhibition in New York as 'Urban Aboriginal Artists' whose 'most peculiarly Australian characteristic of their work is the lesson they carry from their bush-dwelling cousins'.[54] Such is the politics of my position.

I am fortunate that there are people who have the awareness, inclination and ability to understand my work and who are involved in similar critical projects within their own fields. I have consistently drawn succour from these people through reading and responding intuitively in my work; while at the same time being driven by the continued negative stereotyping of Aboriginal people through the mass media and in general conversational contexts in which I find myself. The recent Royal Commission into Aboriginal Deaths in Custody, Commissioner Elliott Johnston QC, expressed his shock at the constancy of non-Aboriginal Australia's treatment of Aboriginal people as if they were inferior. He identified the 'pinpricking domination, abuse of

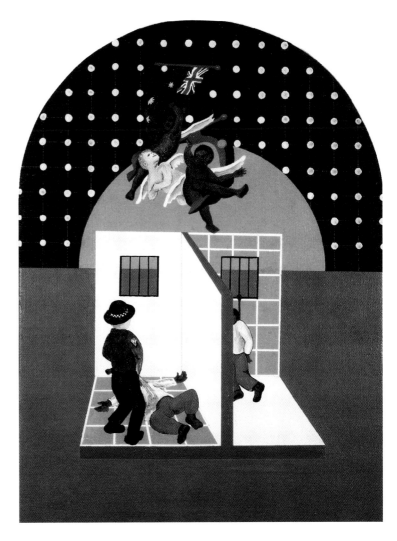

Top left: Figure 26
1993
Ask a Policeman
30 x 20 cm
Soft ground etching on paper
Courtesy Bellas and Sutton Galleries
Photo: Richard Stringer

Above: Figure 27
1994
Couldn't be Fairer
40 x 30 cm
Acrylic on wood
Collection: Private
Photo: Kenneth Pleban

personal power, utter paternalism, open contempt and total indifference with which so many Aboriginal people were visited on a day-to-day basis'.[55]

I have tried to avoid any simplistic critical containment or stylistic categorisation as an 'Aboriginal' artist producing 'Aboriginal Art', by consistently changing stylistic directions and by producing work that does not sit easily in the confines of 'Aboriginal Art' collections or definitions. At the same time I have resisted being positioned as a 'spokesperson for my people' — since I do not have, nor do I seek, such a mandate — by declining to speak about my work. I am close to abandoning my project altogether in an attempt to avoid banal containment as a professional Aborigine, which both misrepresents me and denies my upbringing and Scottish/English heritage.

In the face of institutionalised racism I have considered leaving Australia so my daughter can grow up without having to face a life circumscribed by it. There may be nowhere on this planet where racism doesn't exist, but at least it won't be so close to the bone; it won't be felt

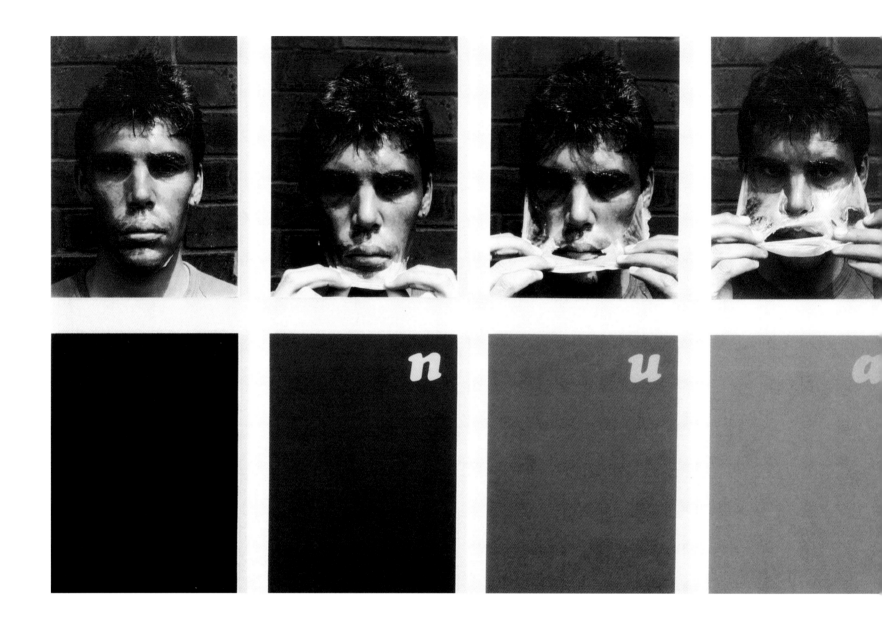

on her pulse. I don't want to experience the first time she comes home in tears because of racist taunts, and I don't want to have to tell her that it's just their ignorance and insecurity that makes them say racist things because I don't think ignorance can be an excuse any longer.

One of the long-term goals for my work is to have my paintings returned to the pages of text books from which many of the images in them originated, where they may act as sites around which a more 'enlightened' kind of knowledge may circulate; perhaps a knowledge that is understood from the outset as culturally relative, which is not to say that this relativity should be feared as an attack on a cultures system of values, but to recognise the equal validity of the values and basic humanity of others. This would involve a kind of critical awareness in thinking that would be anti-racist, or non-racist in the sense that identity would not be the source of self-assertion and exclusion, but a target of a

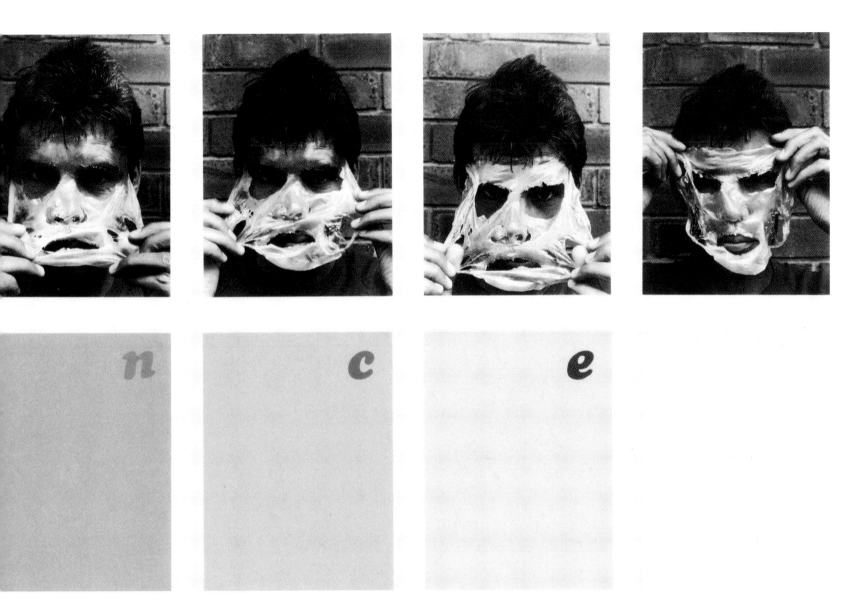

Figure 28
1992
Untitled (Nuance)
85 x 275 cm overall
Photographs and acrylic on foamcore
Courtesy Bellas and Sutton Galleries
Photo: Richard Stringer

questioning through which people might start to depart from the historical limits of their identifications.[56]

One question might be: 'can we today invent a free discourse that would take up again the question of the art of living, through an activity of thought which would not base its way of speaking truly on any given positive knowledge about ourselves or our world, or any theory of government presumed to be final or sufficient, a critical philosophy that in questioning such knowledge and such theory, would open new possibilities in what we might become?'[57]

Bain Attwood, a lecturer in History at Monash University has written in his introduction to the book Power, Knowledge and Aborigines:

The domain of Aboriginal Studies has . . . started to change in theoretical terms. Two inter-related developments can be pinpointed. First, Aborigines are viewed as socially

constructed subjects with identities which are relational and dynamic rather than oppositional (in the binary sense) and given. This challenge to essentialism and the teleological assumptions embedded in Aboriginalist scholarship involves historicising the processes that have constructed Aborigines, thus revealing how Aboriginal identity has been fluid and shifting, and above all contingent on colonial power relations. This approach necessarily involves a new object of knowledge — Ourselves, European Australians, rather than Them, the Aborigines — and this entails a consideration of the nature of our colonising culture and the nature of our knowledge and power relations to Aborigines.[58]

This means opening up 'the locked cupboard of our history' where the crimes we have 'perpetrated upon Australia's first inhabitants' have lain hidden, and coming 'to terms with the continuing Aboriginal presence'.[59]

 In the end I am aware that the quest for freedom from frameworks becomes simply another framework. The self remains relative, and cannot escape into the absolute. Modern scientific thought, finally, has evolved a composite view of the self as a shifting ripple in the Heraclitean river.[60] I once read a book by Hermann Hesse, in the early 1980s, called *Siddhartha* about a man's search for enlightenment. He eventually found it through his reflection in a river, not a still pond; and he didn't fall in love with his own reflection as did Narcissus. What he saw was a 'panorama' of the past, the present, and the future in a state of ever-flowing flux with his 'self' but one moment in that cyclic continuum. If we think of Australia as Narcissus-like, obsessed with its self-image, gazing into the mirror surface of a still pond, then perhaps my work may be understood as one of many disruptions sending ripples across its surface.

Figure 29
1989
Siddhartha's Dreaming
100 x 100 cm
Oil on canvas
Collection: Private (destroyed by fire)
Photo: Gordon Bennett

Painting a History of the Self in Postcolonial Australia:
Gordon Bennett's Existentialism

What is the home, and how to frame it? This, the unanswered question in Australian cultural politics, signals the extent to which Australia is still a migrant culture — that is, one in which the tropes of colonialism (of discovery, invasion and settlement) stage subjecthood.

The difficulty of staging identity in Australia can not be underestimated. The shifting borders of Australian subjectivities are too transparent for a secure subjecthood. The colonial and migrant selves remain divided, decentred, at sea. In this respect Imants Tillers, the Australian postmodernist artist of Latvian parents, is typical of non-Aboriginal Australians. 'I have', he said, 'inherited two cultural identities, but through this fact, ironically, I also belong fully to neither.'[1]

Historically, non-Aboriginal Australians have sought to negotiate a subjectivity in three ways: by either purloining the identity of their origin, or by seeking a new nativism sprung from a *terra nullius*, or, as Tillers suggests, by substituting identity for the metaphysics of rootlessness. However such migrant identities will always fall short of subjecthood because they are not constituted by the 'Other'. Subjectivity, said Jean-Paul Sartre, is not derived from an essence of an individual, culture or place, it is not produced by a sameness but by the 'appearance of the Other'.[2]

If Sartre was keen to secure the agency of individuals, he, like Jacques Lacan, grounded this agency in a split consciousness which must negotiate its being through the desires of what they each called 'the Other'.[3] Applying their theories of subjectivity to colonial situations, it is evident that non-Aboriginal Australians have failed to negotiate an indigenity or subjecthood for themselves because they are not reconciled with their colonised others, the indigenous peoples of Australia. Aborigines have been made the invisible unconscious of an Australian subjectivity which does not know itself. Non-Aboriginal Australians, for all their migrantology, have not gone out in the world, but in their minds stayed at home. The excess of roots experienced by the migrant moving out in the world becomes a rootlessness, a loss.

Recent debates in Australia on republicanism, sovereignty (eg. land rights) and citizenship are signs of a shift occurring in Australia's sense of identity which might reach beyond its migrant

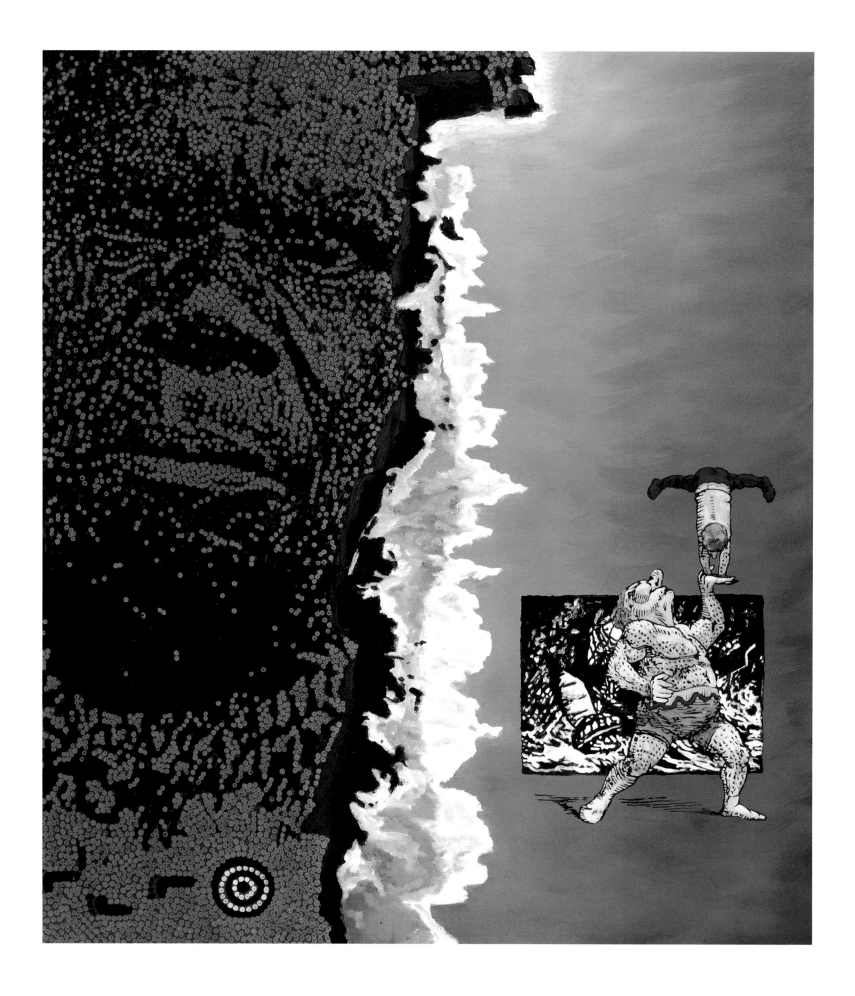

Above: Figure 30
1992
Fig One (Gulf)
130 x 324 cm
Oil and acrylic on canvas
Collection: Art Gallery of South Australia
Photo: Courtesy of Art Gallery of South Australia

Left: Figure 31
1994
Men with Weapons (Corridor)
89 x 232 cm
Acrylic on linen
Collection: Private
Photo: Gordon Bennett

formation. It is such a post-migrantology which Bennett's art seems to explicitly address. This shift of national consciousness was inaugurated in Australia's bicentennial year (1988), the year in which Bennett completed art school. Events since then, such as Prime Minister Paul Keating's Redfern address and the Mabo High Court ruling, suggest that non-Aboriginal Australians are, for the first time, facing and wanting to be reconciled with the Other of their history.[4]

If anything is to come of this, a radical shift in attitudes to Aboriginal cultures by non-Aboriginal Australians will have to occur. To date, Aboriginal cultures, the historical Other of Australian colonialism, have never been allowed to appear except as fetishes of Western and colonial desire — usually as emblems of primitivism. While Aborigines have sometimes been made symbols of the land itself, and even of an ontological rootlessness, their own radical otherness (or self-identities) has been repressed rather than engaged with. In order to escape the shadow of racism and colonialism which is cast across all Australian art, Aboriginal and non-

Opposite: Plate 27
1989
The Great Necrophiliac
100 x 90 cm
Oil and acrylic on canvas
Collection: Private
Photo: Phillip Andrews

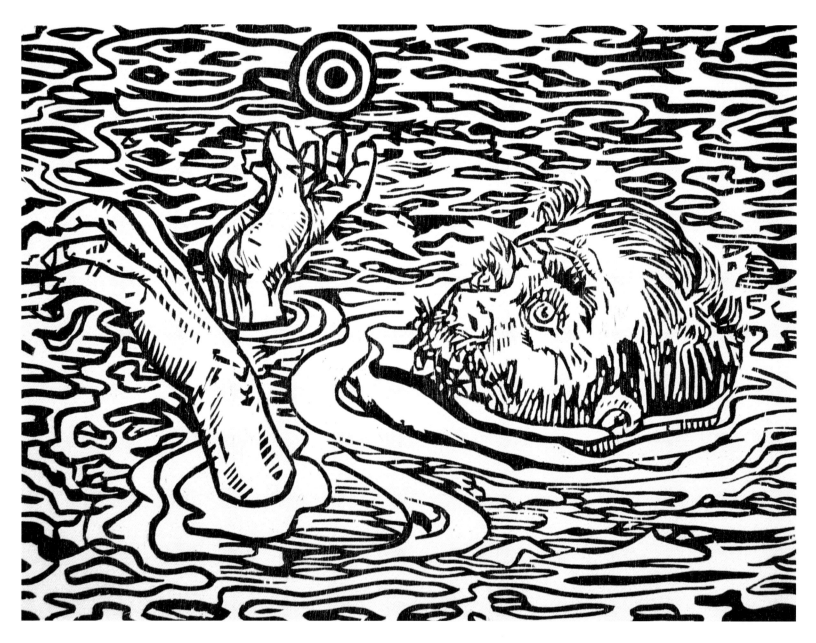

Figure 32
1993
Explorer (The Inland Sea)
45.5 x 61 cm
Woodcut on Japanese paper
Courtesy Bellas and Sutton Galleries
Photo: Gordon Bennett

Aboriginal, the desires of Aboriginal Australians have also to be recognised and analysed. Bennett does this within the frame of existential and psychoanalytical notions of agency, identity and subjectivity. He does not take the quick route to identity by seeking the centred discourses of nationalism and Aboriginalism, but recognises that identity is an existential project in which 'the Other determines me', for (said Sartre) it is only 'through the world [ie. through others] that I make known to myself what I am.'[5]

Western discourse has a propensity to other the 'Other' in a politics of negation through binary opposition. However, says Sartre, the relationship between identity and otherness is not one of 'a frontal opposition but rather an oblique interdependence.' To be 'in-the-world' or with others, is 'not to be ensnared in it' (or in otherness), but is a type of *'habitation or haunting'*.[6]

Likewise, Bennett's art is not a simple story of one side against the other (as is most colonial discourses), or of the collapse of one into the other (as is much postmodernist art), but of the haunting of each side in the other. Thus his often brutally direct subject matter, which relays stories of straightforward murder, theft and invasion, have never offered straightforward scenarios.

Bennett's pictures leave us with questions rather than answers, with complexities rather than simplicities – as if the origins of truth, identity and ideology are in metaphors and signs rather than in things, and hence are layered and relative. To this extent it might be said that Bennett's paintings emulate both traditional Aboriginal art and postmodernist practices. But those who see either an Aboriginal artist or a postmodernist, miss the most salient characteristic of his art: it is first of all an existential project of self-revelation and even self-redemption. His pictures are, at their most profound levels, autobiographies in which Bennett's own self is a site of ideological conflict — a conflict which calls into question Western notions of agency, in particular, of his ability to make himself without others. Here autobiography becomes what Nikos Papastergiadis called 'allography', or the writing of the other.[7]

Put in an historical context, it could be said that Bennett's personal philosophical and spiritual agenda is crossed with the politics of the Australian nation, for the antipodean origin of Australia as the other of Europe and the place of Europe's primitive other parallels on a social scale Bennett's personal predicament. In this sense, Bennett's work astutely addresses a prevailing issue, and even malaise of our time and place: the failure to know (or at least agree) who we (Australians) are. Moreover, Bennett's project of self-redemption is analogous to one of national salvation because he will not be redeemed unless the place is. The nation's redemption is an essential medicine for his own cure. Bennett's problem is ours. However, if he also suffers from a surfeit of identities, the legacy of his Aboriginal descent puts a different spin on the rootlessness experienced by non-Aboriginal Australians.

To date, most non-Aboriginal Australian artists have repressed the issue of Aboriginality by keeping those of migration centre-stage. In other words, they have remained circumscribed by the 'provincialism problem'. Their horizon and ambition was to be the same as the centres on the other side of the world. The history of Australian art has been the story of the repression of differences, so that the local Australian scene could be made to correspond to Eurocentric norms. Australia's radical otherness was re-shaped into the familiar icons of Western culture: into a grotesque Australia, a picturesque Australia, a sublime Australia, an Aboriginalist (read primitivist) Australia, a postmodern Australia, and sometimes even a paradise. In Tillers' words, locality failed; there is no centre. Here all things, including all things 'Aboriginal', are reduced to one more

commodity for appropriation. Whether this community is imagined in terms of Aborigines on walkabout, or the bushie on the wallaby track, or postmodernists surfing global media vectors, it comprises nomads in a *terra nullius* — all of which are metaphors for a politics of loss.

While it is a commonplace today for artists to assume that there is no centred subject, Bennett is one of the few Australian artists to frame the condition of centrelessness in terms which are specific to the Australian experience of colonialism. If Bennett also recognises the indeterminacy and homelessness of his existence, he doesn't idealise it in a nostalgia for home, or the freedom of a postmodern in-betweenness, but locates his diaspora within the history of colonialism. This is partly why he has described himself as a 'history painter'. However, what he means by 'history' can not be presumed, for he wants to undo the various histories of colonialism, from the grotesque to the postmodern Australia's, in order to make visible what they repress. His historiography is a psychoanalytical deconstruction designed to trace the unconscious of Australian identity.

The irony of Bennett's claim to be a history painter signals the complexity of his aesthetic ambition. History painting is a time-honoured tradition in Western art. Much like the ascendancy of theory in art schools today, for well into the nineteenth century history painting was a privileged practice designed to distinguish the articulation of ideas from the mere expression of technical expertise. Its aesthetic derived from what Alberti called *istoria*, or the ennobling virtues of art developed by the "Ancients". The history painter did not blindly copy nature, but followed the Masters, or what was called the "great style", thus ensuring the rule of a Eurocentric classical genealogy which its defenders traced to the ancient Greeks.

It might seem reasonable to infer that Bennett means to be a modern day historiographer tracing contemporary events, not an academic history painter intent on replaying the ennobling virtues of Ancient Greeks. However Bennett's historiography is ambiguous. Despite his claim to be a history painter, Bennett wants to undo the hold of the usual stories told by modern historians. He is interested in what Australia's historians do not say, in what they leave out — or more exactly, in mapping what might be called, after Jung, the shadow of Aboriginality in Australian historiography.[8] Bennett is not the chronicler of Australia's history, but its exorcist. According to Bennett, Australia's colonial history has repressed Aboriginal others who haunt its texts. Bennett's historiography has a psychoanalytical purpose that writes against the grain of History (ie. against the ways in which Australia has been consciously imagined by its traditional artists and writers) by tracing the discourses and desires of Aboriginal others.

On the one hand Bennett's conception of history painting is a type of anti-history in keeping with the practices of the most radical modernists. On the other hand, he distances

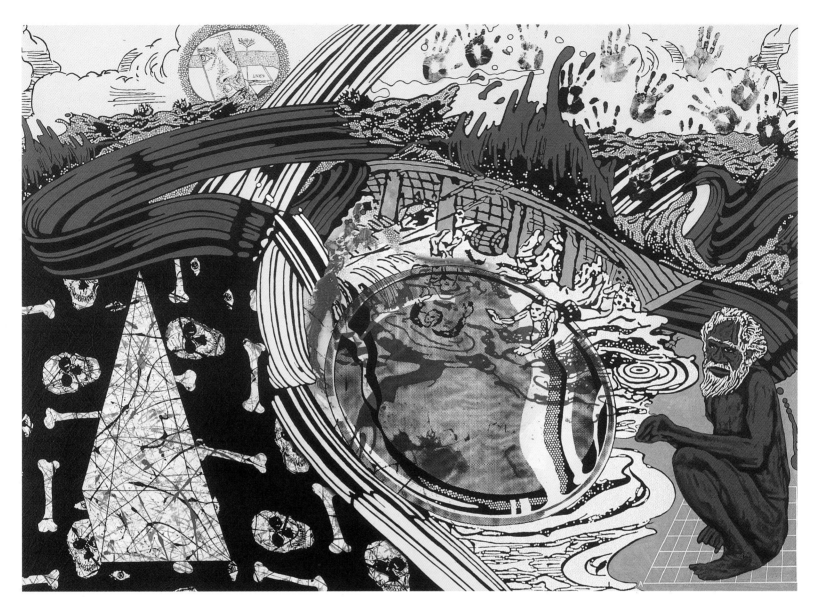

Plate 28
1995
Big Baroque Painting (The Inland Sea)
220 x 312 cm
Acrylic on canvas
Collection: Queensland University of
Technology
Photo: Sam Charlton

himself from the unhistorical tenor of Euro-Australian art which, with a few exceptions, is a landscape aesthetic that ignores the figurative tradition of history painting. Further, and tangential to the previous two points, like the traditional History painter he proclaims a history of ideas over mimesis; ideas which stage the possibility of redemption. In 'questioning the ways our own history defines us', he claims to be seeking 'the art of a beautiful life or the ancient notion of noble existence.'[9] In short, Bennett's project does not directly oppose one type of history with another, or one aesthetic with another, but maps the oblique paths by which these different conceptions of history and their applications to Australia, might cross over. He seeks to expose the shadows of official 'history', to track its doubles and contradictions, not in order to repudiate the European vision, but to map a postcolonial future.

Philosophy and Painting:
Gordon Bennett's Critical Aesthetic

Bennett's aesthetic concerns are, to an extent rarely seen in Australian art, staged by philosophy. This has been evident since his student work. *The Persistence of Language* (August–November 1987) and *The Coming of the Light* (August–November 1987), painted during his second year at art school, suggest an affinity with the precepts of French phenomenology and existentialism. By the time he graduated at the end of 1988, Bennett was also clearly interested in the aesthetic strategies of postmodernism.

While existentialism, phenomenology and postmodernism are, in many respects, hostile to each other, all are sceptical of the cognitive and ocular traditions of Western thought, and alive to the central role of language in ideology. The principle aesthetic idea of Bennett's painting is that ideology is an effect of language, and that the specular codes of traditional Western knowledge (in its arts and sciences) have obscured as much as they have revealed. He painted the incommensurability between the white world his eyes saw every day, and its Aboriginal heritage. This is why postmodernism suited the purposes of Bennett's art: its deconstructive methodology provided ways to re-present what had been foreclosed by the history of Europeans bringing Enlightenment to the antipodes. All of his work is founded on the presumption that the language of Enlightenment introduced by colonialism was, for Aborigines, a prison-house they could not escape, but only appropriate.

Bennett's suspicion of the specular codes of Enlightenment are amply evident in his paintings. In particular, he discounts the metaphysics of presence through processes of othering. For example, while he works in a figurative mode, he inserts text, diagrams and illustrations which break the magic spell of the autonomous three-dimensional space of Western painting. Thus Bennett does not repudiate the figurative tradition of Western art, but deconstructs it. Because the Enlightenment brought to Australia will not go away, Bennett has no choice but to employ postmodernist strategies which, unable to transcend the despotism of the eye (which Bennett eventually figured in perspectival diagrams) are

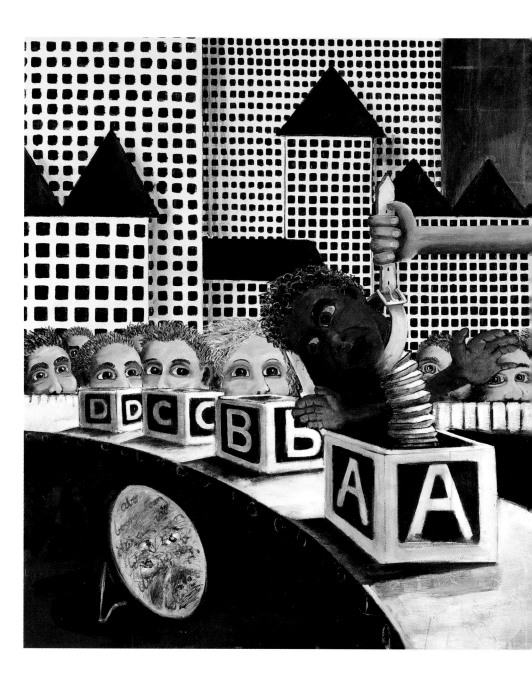

Plate 29
1987
The Coming of the Light
Two panels 152 x 374 cm
Acrylic on canvas
Collection: The Artist
Photo: Gordon Bennett

condemned to continually traverse them. His is a redemption that never happens, a make-shift remedy made from the poisons which cause his malaise.

Bennett's disdain for the virtues of Enlightenment is apparent from his earliest work, particularly in his upsetting of the linear logic of reason, usually through irony. For example, the title of *The Coming of the Light* (1987) ironically remembers a Torres Strait Islander's description of the coming of the missionaries. The irony cuts several ways. In one sense the missionaries are the vanguard of Enlightenment, and Bennett does deliberately parody their metaphors of Enlightenment. However Bennett also recycles the Christian myths of salvation and sacrifice for his own purposes: 'Will he come . . . will Elias come to save him'. Yet the patheticness of this plea spotlights, as it did at the cross of Jesus, the unfolding tragedy. God does not come, not

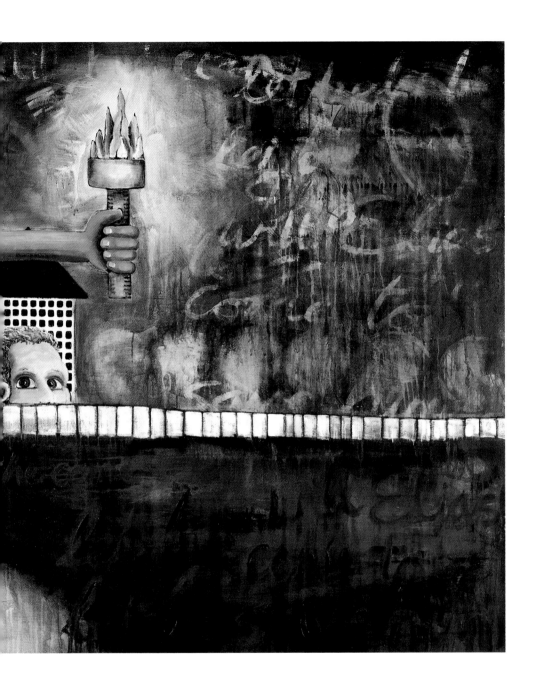

now at least. The crucifixion continues, and Jesus must endure his spell in Hades.

Bennett's message, repeated again and again in his paintings, is that the oppression of Aborigines is a direct result of Enlightenment. In *The Coming of the Light* one hand holds the torch of reason whose white light feebly illuminates the dark night, the other hand humiliates an Aboriginal subject. It was not just guns, disease and poison, but the language and institutions associated with the culture of Enlightenment which voodoo-like killed and still kills Aborigines. In *The Persistence of Language* (Figure 8, p. 20), the third panel of a large Goyaesque triptych depicting the colonised's progress, the abuse of words savage the black body hung limp from a rope in the prison cell. Here Bennett places the viewer in the perspective of the Aboriginal prisoner: the dark interior cell becomes a figure of the viewer's mind looking out through the

bars which are our eyes onto the leering world of white civilisation, while inside reverberate the stabbing shouts KOON, NIGGER, BOONG, ABO.

In Bennett's scheme the light of Enlightenment emanated from an evil eye. The gloomy gift of this light is the prison-house of language, signified in *The Coming of the Light* by the sharp architecture looming monstrous-like behind the speechless white faces. These white gods have nothing to say, they do not look, they cannot see. They are staring eyes, as if the eyes of the blind or the mad. Like the dark rows of windows behind them, these white eyes do not receive or return our look, but are caught in a rigid trance. They are the terrifying gaze of the other which, said the French poststructuralist theorist Jacques Lacan, constitutes the symbolic realm of language. This 'field of the gaze', as he called it, 'has nothing to do with vision as such'; rather it commands, it institutes the symbolic means by which 'civilisation' rules: the order of reason, the rigid geometry of perspective.[1]

In Bennett's painting, the grid of 'civilisation' exemplified in the image of the city stands behind and contains the white bodies. Outside the space of the grid is the monstrous 'jack in the box' black figure being absurdly and comically ejected from its box. This black Aboriginal figure, choking as it is hauled from the box of language by the arm of Enlightenment, is the object of the white gaze of Enlightenment. Its difference from the white world is ideological rather than absolute — the result of a binary logic not of its own making. It is stuck at the opposite end of the arm of Enlightenment which holds aloft the white light. Here its grotesque fate is held in balance — the scales of justice perfectly horizontal. In what seems the black man's last moments, he glances down to a mirror which returns the verdict of Enlightenment: the abusive shouts of 'abo' and 'boong' which objectified him as a monstrous superfluous thing.

The coming of the Enlightenment is White Justice, what Jean-Paul Sartre called 'a racist humanism' by which 'the European has only been able to become a man through creating slaves and monsters'.[2] According to Bennett the coming of Enlightenment to Australia created a binary space, an apartheid, what Frantz Fanon called a 'manichean world'. It was manichean because 'no conciliation is possible, for of the two terms, one is superfluous'. It 'is no more and no less than the abolition of one zone, its burial in the depths of the earth or its expulsion from the country'.[3]

If *The Coming of the Light* pictures the poison of Enlightenment in terms of its specular codes (its fetishes of sight and light), this large painting also stares back at us as if it also is a fetish or a symbol in its own right, its gaze undoing in its ironic presentations a history of colonial oppression. By its 'steady and corrosive gaze, we are picked to the bone'.[4] From poison Bennett makes a bizarre medicine. Forty years earlier Sartre had put it plainly and in terms specific to what is achieved in this painting:

What would you expect to find, when the muzzle that has silenced the voices of black men is removed? That they would thunder your praise? When these heads that our fathers have forced to the very ground are risen, do you expect to read adoration in their eyes? . . . I want you to feel, as I, the sensations of being seen. For the white man has enjoyed for three thousand years the privilege of seeing without being seen. It was a seeing pure and uncomplicated; the light of the eyes drew all things from their primeval darkness. The whiteness of his skin was a further aspect of vision, a light condensed. The white man, white because he was a man, white like the day, white as truth is white, white like virtue, lighted like a torch all creation; he unfolded the essence, secret and white, of existence. Today, these black men have fixed their gaze upon us, and our gaze is thrown back into our eyes.[5]

While *The Coming of the Light* includes what would become aesthetic devices of Bennett's later deconstructive paintings, such as references to the mirror, appropriation, the use of text and the alphabet as coordinates of an imprisoning code, the painting remains within a metaphysical rather than deconstructive frame.[6] Bennett's penchant for the transcendental idealism of metaphysics is evident in the presence he gives to a large dark area which the torch only momentarily and hesitantly illuminates. If in later works Bennett often includes similar zones in the form of black bands and squares, and even the fold between two images butted together, they lack a transcendental purpose. Instead, they become part of a deconstructive strategy to articulate something other and in-between that is excluded in the presence of an image. Here the appropriation of other artists' works is an ironic homage: it is not only a salute, as is the gesture to Colin McCahon in *The Coming of the Light*, but also the subject whose presence is to be deconstructed.

The shift from metaphysical concerns to the deconstructive aesthetic of postmodernism occurred in a series of allegorical paintings made during Bennett's last year at art school (in 1988). Here he began to survey a space between phenomenology and deconstruction, a problematic zone whose contradictions have since structured his work. Indeed, Bennett never fully discarded his metaphysical concerns. His enthusiastic turn towards deconstruction in the latter half of 1988 was soon qualified by a refusal to leave behind metaphysical and phenomenological issues. He remains an existentialist at heart — as is born out in the series of

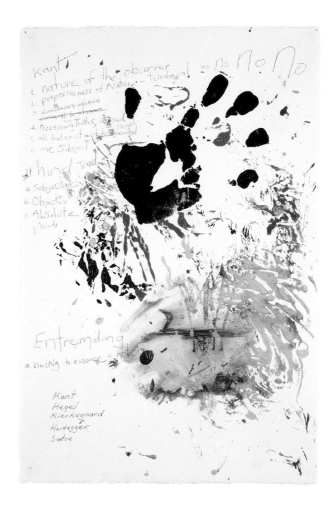

Figure 33
1995
Nature of the Observer
58 x 38 cm
Mixed media on paper
Collection: Private
Photo: Kenneth Pleban

mixed media work completed in May 1995.[7] He is, then, a reluctant postmodernist. First, he appropriates for instrumental not epistemological purposes. That is, he has clear socio/historical objectives in mind. Second, his appropriations draw attention to the textual and ideological objectives and content of his critique. Third, when Bennett appropriates, he also seeks to counter its deliberate semiological estrangements with an existential search for an interior metaphysical meaning. Appropriation, which strips meaning from things, and its opposite existential reclamation of meaning, combine as the chiaroscuro of Bennett's art. Thus the *Outsider* (March 1988), one of the first paintings to register Bennett's shift towards a more deconstructive mode, is both a homage to and a deconstruction of Vincent Van Gogh's *Vincent's Bedroom in Arles* (1888) and *Starry Night* (1889) — or at least of the ways in which such paintings by Van Gogh have been received.

Van Gogh is a favourite painter of Bennett's. In 1990 he made his first trip overseas to see the mammoth retrospective in Amsterdam, exhibited on the centenary of Van Gogh's death. Bennett identified with Van Gogh's own tortured life — the *Outsider* (1988) being a centenary salute to *Vincent's Bedroom in Arles* (1888), and a salute made on the bicentenary of Australia's foundation. In this context, *Outsider* can also be considered Bennett's unofficial (and ironical) contribution to Australia's bicentenary celebrations.

Bennett identified with Van Gogh's metaphysical quest for meaning and identity, and more particularly, with his compulsion to show the darkness in light, for in painting the sun and sunflowers Van Gogh depicted a dark interior world that was nevertheless redemptive. His paintings are emblems of a modern spirituality as if, like Christ, Van Gogh's own painful life was transcended in his paintings of light and colour. The sunflowers which were his medicine are also the remedy for our own tortured world.

The *Outsider* raises more questions than it answers. In some respects it retains the expressionist metaphysical concerns of Bennett's earlier work; Van Gogh, it should be remembered, is an essential figure in a genealogy inherited by the contemporary artists that Bennett then admired, such as McCahon, Guston and Booth — a genealogy which Bennett here seems to pay his respects to. Moreover, as in his earlier work, the *Outsider* includes a large dark metaphysical zone, here drawn from Van Gogh's *Starry Night*. For Van Gogh the starry night was a forboding of death and the return to an ultimate peace for which he longed. Bennett seems to deliberately take on this theme, what Derrida called an 'allo- and thanatography' (the script of the Other and of death).[8] However there is a marked difference in tone between Van Gogh's and Bennett's bedrooms. The tense calmness of Van Gogh's depictions of his humble bedroom in Arles pictures his personal fate. In this room Van Gogh waited in vain for the redemption which

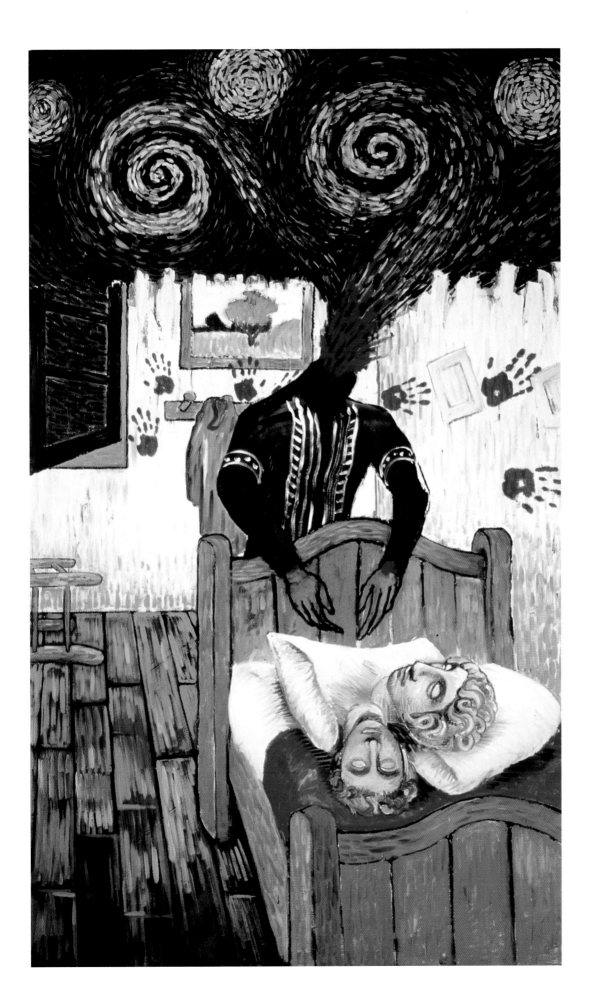

Plate 30
1988
Outsider
290 x 180 cm
Oil and acrylic on canvas
Collection: University of Queensland
Photo: Courtesy University of
Queensland

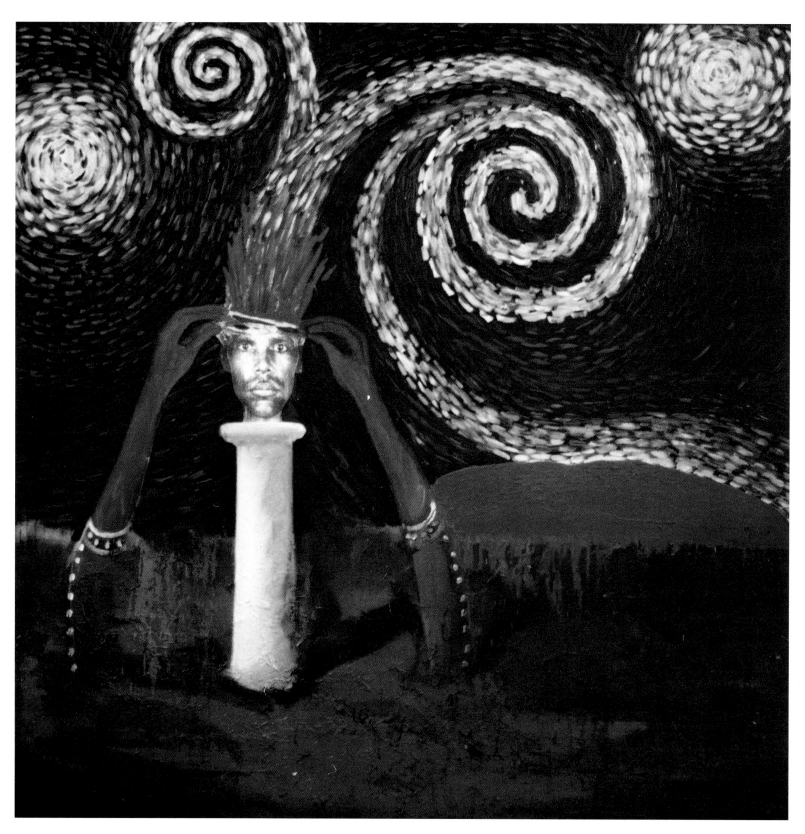

Figure 34
1988
Self Portrait
179 x 175 cm
Oil on canvas
Collection: The Artist
Photo: Gordon Bennett

he hoped Gauguin would bring him. In about six weeks he would mutilate his body in protest at his fate. On one level, if Bennett's *Outsider* shows that Van Gogh's realistic picture of a humble room was in fact a self-portrait full of prophecy and psychoanalytical premonitions, on another level Bennett's own violent ritual in the bedroom is transparently staged, his mutilation a public theatre rather than a private act of desperation. Here any auto-biographical intention of the painting is subsumed in a social allegory of the contested identities of Australians in which redemption is not found in a cosmic death, but in an Aboriginal history. If in Van Gogh's *Starry Night* the sky is dominated by a large ying yang pattern, the Taoist symbol of harmony and the universe, Bennett's (mis)appropriation omits it, despite his interest in Taoism. The dots and dashes and roundels in Bennett's starry night suggest Western Desert Aboriginal paintings — the first instance in which Bennett makes such allusions in his work.[9]

Bennett's *Outsider* qualifies both the personal and mystical associations of Van Gogh's work by blatantly and shockingly visualising the trauma which *Vincent's Bedroom in Arles* only symbolises, keeps invisible. In this sense Bennett's painting is a deconstruction which makes visible the politics of loneliness. Bennett's portrait is equally that of a schizophrenic nation than of his own particular self; an 'Australia' which here figuratively displays his own dilemma of violently contested genealogies. What was that other voice which Van Gogh attempted to silence when he sliced his ear from his head? What palette is made from this blood spurting from the black decapitated neck as the bloodied hands reach towards or draw away from the white Greek marbled heads on the bed? What do they now dream, eyes closed, bodiless; and what picture is the blood they released painting over *Vincent's Bedroom in Arles*?

Michel Foucault claimed that Van Gogh, and the 'frequency in the modern world of works of art that explode out of madness', 'opens a void, a moment of silence, a question without answer, provokes a breach without reconciliation where the world is forced to question itself . . . the world is made aware of its guilt'.[10] Bennett's *Outsider* accomplishes the same task, but in an opposite way. Rather than being interrupted by madness, as Foucault claimed of Van Gogh's work, the *Outsider* interrupts the madness of the world — and here the Euro-Australian world whose ordered bedrooms are inhabited by Aboriginal ghosts, by grotesque secrets which have already instituted a 'breach'. And it was this 'breach' which Bennett's own self embodied.

So who is the *Outsider*? Bennett, Van Gogh, the mad void or silence of Australian history? The answer is yes, yes, yes, and . . . ! Bennett's *Outsider* reaches beyond its narrative task to question and at the same time re-frame the issue of identity and its role in self-portraiture. Self-portraiture appears the most psycho-analytical genre because upon the face of the individual is written, or shown to be written, the story of a life. It is a cliche that the eyes are windows to the

Figure 35
1988
Requiem for a Self Portrait
175 x 179 cm
Mixed media on canvas
Collection: The Artist
Photo: Gordon Bennett

soul. Such was the force of Van Gogh's numerous self-portraits that his landscapes and still lifes are also often read as self-portraits, as windows to his soul. If Bennett did not conceive the *Outsider* as a self-portrait, the painting of this picture staged, for him, the possibility of self-portraiture, and the impossibility of conceiving 'Australia' outside of his own subjectivity. Within a month of finishing *Outsider*, Bennett began painting a self-portrait derived from it. However, he could only paint a self-portrait through the frame of history, not notions of individualism. Thus this, his first conscious self-portrait, eventually became *Requiem for a Self-Portrait* — its imagery obliterated under a skein of black paint. Bennett jokingly refers to it as his first abstract painting. His first conscious attempt to portray himself produced an image of obliteration and death, a requiem.

Bennett's picturings of his psyche framed the narcissistic staging of his conception of history painting. Since then his art has consistently staged his own self, but within the context of history painting rather than traditional self-portraiture. Bennett cannot conceive himself, his individuality, outside of history; just as he cannot read history except through his own experiences. His is a psychoanalytical historiography, his notion of self-portraiture and history painting being unresolved 'psycho-dramas' rather than the emblems of transcendence and fortitude that they have traditionally been in Western art. The impossibility of painting the portrait of a man irrevocably divided by the ideology of his upbringing and of his place, is the haunting dilemma of Bennett's art. It is also the dilemma of being an Australian; and it is here, in mapping and understanding this dilemma, that Bennett found deconstruction a useful aesthetic strategy. It allowed him to inter-weave the narcissism of his project with a genealogical and historical account.

Deconstruction is a space of undecidability in which structures that seem to hold subjects in a rigid frame dissemble. For Bennett the mirror, which provides the principle motif for the self-portraitist, came to represent this space. This is not an original idea, the metaphor of the mirror having an impressive pedigree as the emblem of an imaginative space. If the mirror is where we inspect ourselves, the inspection is not a passive survey of the self, but a dynamic means to reconstruct and imagine ourselves differently. Before the mirror we make ourselves up. Hence the mirror is a metaphor for an imaginary liminal space in which, as Alice discovered, anything is possible, the former boundaries and limits of things dissolve, and even the grotesque appears normal. Because the mirror image is a reversed figure, it is also often conceived as a doorway to another inverted fantastic world, an antipodes, the realm of the 'Other'. Bennett put a mirror (rather than a microscope) to Australia, thus picturing a narcissistic historiography. For him the reflective surface of the mirror not only upturns (inverts) the real world of colonialism,

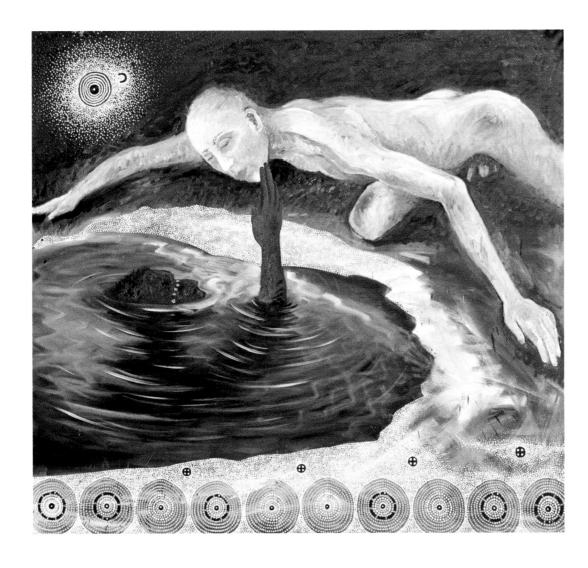

Plate 31
1988
Echo and Narcissus
179.5 x 200 cm
Oil and acrylic on canvas
Collection: Private
Photo: Gordon Bennett

but is an icon of the corrosive threshold between the coloniser and colonised, a liminal zone where the discourses of colonialism are exceeded, the past and future re-negotiated, and history re-written. This strategy was first consciously glimpsed in *Echo and Narcissus*, completed in July 1988, shortly after the *Outsider*.

The Narcissus myth is ostensibly a story of the relation between identity and sexual desire. At another level, it traces the action of repression and foreclosure which Freud and Lacan have articulated in their theories of identity and sexual desire. By remaining entrapped in the mirror-phase, unable to repress his own narcissism, Narcissus is, like Echo before him, condemned to foreclosure, to disappearance. At another level, Echo is the alter-ego of Narcissus; she is the repressed origin and 'Other' of Narcissus' own fate. While Narcissus is the principle protagonist of the myth, with the nymph Echo playing a minor role, Narcissus merely retraces the path already trod by Echo. In privileging Echo, Bennett draws attention to what is repressed in the story of Narcissus: that the fate of Narcissus is prefigured by Echo.

Echo had previously been punished by Hera, the wife of Zeus, for distracting Hera with

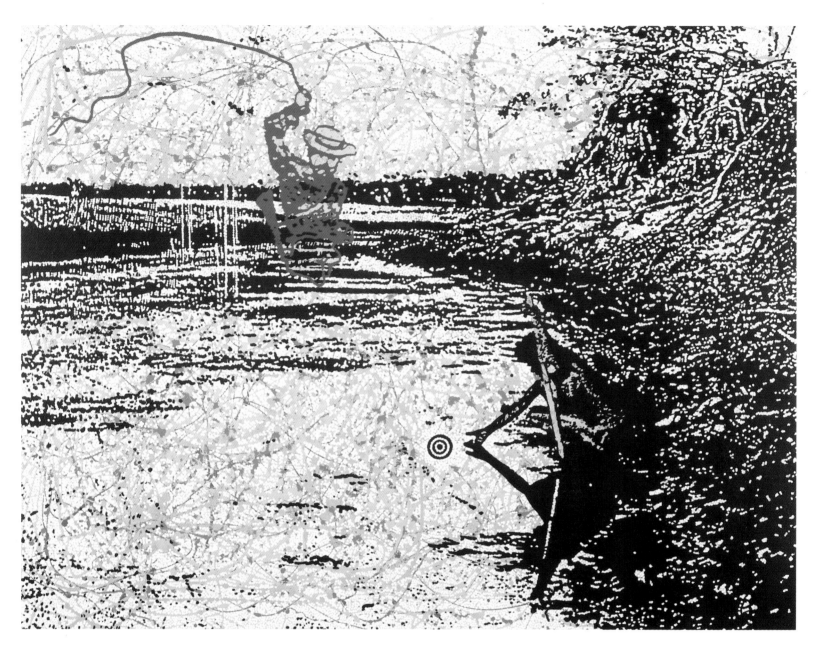

Plate 32
1991
Poet and Muse
170 x 225 cm
Oil and acrylic on canvas
Collection: Private
Photo: Richard Stringer

idle chatter so that Zeus' lovers could make their escape. Echo's punishment was the loss of her own voice and eventually her own body and identity: she could only foolishly repeat or echo another's shout. Her eventual fate was to disappear altogether: unseen, she became part of the earth, her invisible presence only evident as an uncanny echo of another. Unable to articulate her own desires, she is reduced to mimicking the words of others. Hers is a defeated and colonised body; left subjectless, her disabling a type of castration. Without parents and belonging to no place, Echo slowly metamorphosed into the land itself, into caves, grottos and cliffs. But because she is still a (desiring) subject, but no longer an object or body of desire, she is abject. This too, is the eventual fate of Narcissus. Beautiful and youthful, but unable to love the other, he scorned the love of Echo. Reduced to loving only his own mirror image, he

suicides, and is condemned in Hades to eternally gaze at his reflected image. Thus the difference between Echo and Narcissus is ambiguous. In one sense, Narcissus is Echo. Like the Uroborus serpents in the Aboriginal motifs along the bottom of the painting, both are entwined in the same circle of desire, the same genealogy. According to Robert Graves, 'Echo . . . [represents] the mocking ghost of his [Narcissus'] mother'.[11]

Bennett made Echo an Aborigine, her desiring black body only able to become a subject by echoing the new white law. Here Echo's blackness is cast as a Jungian shadow of Narcissus' desire. For Jung, not only do each of us have an alter-ego, unconscious or shadow which projects our fears onto others, but each society has a collective shadow which is expressed in the mythologies of that society, usually as grotesque forms. As with Jungian analysis, the object of Bennett's work is not to expel these shadows, but to know them.[12] In casting the Euro-Australian coloniser as Narcissus, Bennett set the stage for a new understanding of the relationship between Aboriginal and non-Aboriginal Australians. If non-Aboriginal Australians repeat the story of Narcissus, Bennett adds a subtle twist. The reflection which Narcissus sees in the mirror surface of the stream is not that of a restrained white Briton which most non-Aboriginal Australians have generally imagined, but a black Echo who reaches up to stroke his face. Bennett thus makes visible what is repressed in both the myths of Australia and Narcissus: the uncanny embrace of Echo, alter-ego of Narcissus, longing for her own presence.

Bennett's twist significantly departs from the Greek myth. He makes the mirror a metaphor for a place of reconciliation, the waterhole here becoming a place of purification: a place of dreaming, identity and law making — as it is in Aboriginal mythology. This is underscored by the use of dot painting around the edge of the pool, the reference to traditional Aboriginal mythology in the depiction of a snake whose body encircles the pond, and the deployment of Western Desert emblems of waterholes and meeting places in the bottom frame and top right hand corner of the painting. However the reconciliation is a psychic one; the reconciling of white Australia with its Aboriginal other, here depicted as a reflection which shadows the white gaze. Several years later Bennett returned to the theme of Narcissus in *Poet and Muse* (October, 1991), and in what appears to be a detail of *Poet and Muse*, *Explorer and Companion (The Inland Sea)* (February, 1993). But this time Narcissus is an Aborigine who stares into a river or large creek, rather than a pond.[13] Furthermore, in *Explorer and Companion (The Inland Sea)*, Echo is a white explorer reaching out to the black man. If on one level this painting

Figure 36
1993
Explorer and Companion (The Inland Sea)
130 x 162 cm
Acrylic on canvas
Collection: Private
Photo: Vesna Kovac

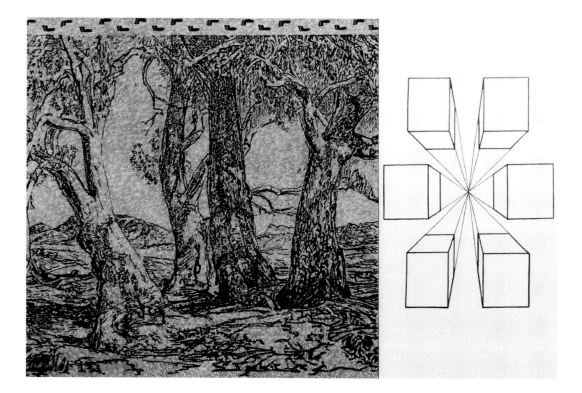

Figure 37
1988
Landscape Painting
105 x 225 cm
Oil and acrylic on canvas
Collection: Private
Photo: Gordon Bennett

alludes to the extent to which Aborigines saved European explorers, it also figures the history of colonialism which shadows Aboriginal history. The postcolonial scene cuts both ways; and this is the only basis of any meaningful reconciliation.

It might also seem that in *Echo and Narcissus* Bennett is alluding to Lacan's famous 'mirror phase', in which the mirror image is the means by which the infant enters the social realm of the law. However, at the time Bennett was unaware of Lacan, and that the narrative of identity and desire told in the myth of Narcissus is central to Freudian and Lacanian texts which underpin much postmodernist and postcolonial theory. Nevertheless, if Bennett's use of the myth of Narcissus runs parallel to rather than develops directly from Freudian and Lacanian ideas, the parallels are significant, and bear on his use of mirrors in later works. In this respect *Echo and Narcissus* is a significant rehearsal of a major theme in Bennett's later work in which the mirror is a central element in the reconciliation that he seeks between the self and its others.

The metaphor of the mirror allows Bennett to implicate the one in the other without reducing one to the other. Rather than being totally separate laws, two opposed systems, non-Aboriginal and Aboriginal Australians become figures of each other, but figures in which their differences are not foreclosed. If in Australia Aborigines have been made the other, the inverted double, the metaphor of the mirror allows their difference to retain an uncanny presence in the narcissistic discourses of non-Aboriginal Australian identity. The 'Australia' which Bennett traces is the tragic affair set in train by colonialism between a black Echo and a white Narcissus, but an

affair whose tragedy can be exceeded (cheated) by transforming the narcissistic regression of colonialism into a deconstructive mimicry, so that Echo can articulate her desires and Narcissus love the other. It is this which locates Bennett's aesthetic in the postcolonial domain.

In occupying the surface (or tain) of the mirror, Bennett exceeds but does not transgress the law of colonialism. While refusing the transcendental domain of the ego as it stares into the mirror, Bennett does not regress to the imaginary domain on the other side of the mirror. Instead he inhabits the threshold between the two, a strategic location from where he can rearticulate but not withdraw from the law. His is a project of deconstruction. 'Deconstruction', said Derrida, 'is not a movement of transgression, of liberation'. Even if, 'in a given situation', it has some of these effects, its subject is language, which is always in the realm of the law.[14] Thus postcolonial artists are primarily interested in the dilemma of Echo: the problem of language; how can the colonised speak? The issues of identity and power are one of language and its theatre. And this is why appropriation became, at this time, a central strategy of Bennett's aesthetic. Like Echo, Bennett can only speak through mimicry; and it is this which differentiates his echoes from the simulacra of much postmodernist appropriation.

Bennett first employed Western Desert signage during his meditations on death and classical themes in the first half of the bicentenary year (1988) — *Echo and Narcissus* being one of the first examples. However, if such usage has left Bennett open to the accusation of appropriation, his appropriations do not have the effect of postmodernist simulacra. Appropriation, says Bennett, is when the artist steals a particular design, or a copyright. Hence the use of the dots and roundels which characterise Western Desert Aboriginal painting is not appropriation. As with Bennett's references to McCahon and Van Gogh, his use of dots and roundels is a homage to a way of picturing the world, not an appropriation of a particular picture or design, or the replication of simulacra.

However, if Bennett does not appropriate Aboriginal designs, he does appropriate Western designs, mainly from social history texts and from artists such as Hans Heysen, Imants Tillers and Roy Lichtenstein. In October 1988 Bennett completed *Landscape Painting,* which inaugurated what has since become a Bennett trademark: the simultaneous submission of an appropriated image to both Aboriginal and Western language systems. On the upper and right hand side of the painting he displays the codes of Aboriginal and European art, running them together in the central appropriated image. That this image was appropriated from a Heysen painting was also important. Heysen was the first Australian artist to make the desert an icon of non-Aboriginal Australia, yet he never showed Aborigines in this landscape. He depicted a *terra nullius,* using what in the nineteenth century was a conscious symbol of an absent Aboriginality: large old

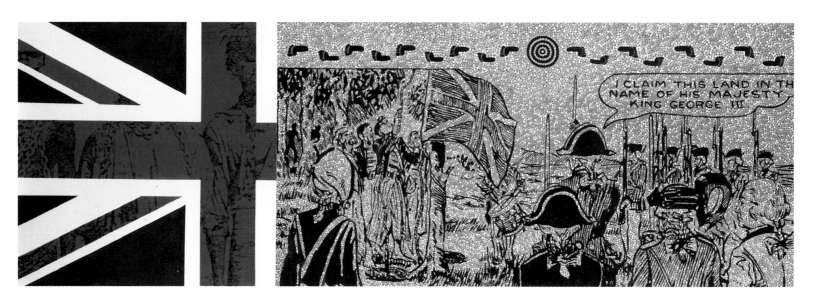

Plate 33
1989
Terra Nullius
75 x 225 cm
Acrylic on canvas
Collection: The Centre Gallery, Gold
Coast
Photo: Courtesy The Centre Gallery,
Gold Coast

gum trees. In Heysen's transcendent vision of a new white Australia, the old river gums are the last traces of a departed empire, the shadow of Aboriginality within 'White Australia'. Bennett's point is clear: such icons of non-Aboriginal Australian identity enact the theft of Aboriginal land.

The result of such appropriation is a cooler more cerebral art, with a distinctive postmodern look. In numerous paintings of late 1988 and 1989, Bennett virtually re-wrote the history of Australian settlement as a story of invasion and genocide. His message was always the same: that the picturing of settlement was a deliberate cover up and an essential part of the colonising process by which Aborigines were humiliated, killed and betrayed. In paintings such as *Prologue: They Sailed Slowly Nearer* (October 1988), and *Terra Nullius* (January 1989), Bennett appropriates images from social history texts. *The Plough* (December 1988 – January 1989) again appropriates a Heysen painting, but this time showing the fields of bones which are the foundation of Australian wealth. Images of nineteenth century colonial paintings are also appropriated, as in *The Betrayal (Pieces of Silver)* (January 1989) and the *Web of Attrition* series (November – December 1989).

Appropriation was valuable to Bennett's purpose because it enabled him to isolate the use of language in pictures. Here Bennett adopts the aesthetic imperative of postmodernist deconstruction, in which ideological content is evaporated to reveal the abstract order which all pictures share. Deconstruction demands a conscious attention to language and the ways in which its codes have commanded presence through foreclosure. *Untitled,* painted in February 1989, graphically illustrates this foreclosure in the picturing of Australian history. While his appropriations of five images from social studies books replicate existing simulacra (ie. existing reproductions), the sixth painting in the series is an abstract piece, a black square. Here Aboriginality has not evaporated, but is repressed in a black Malevich-like square, an absence

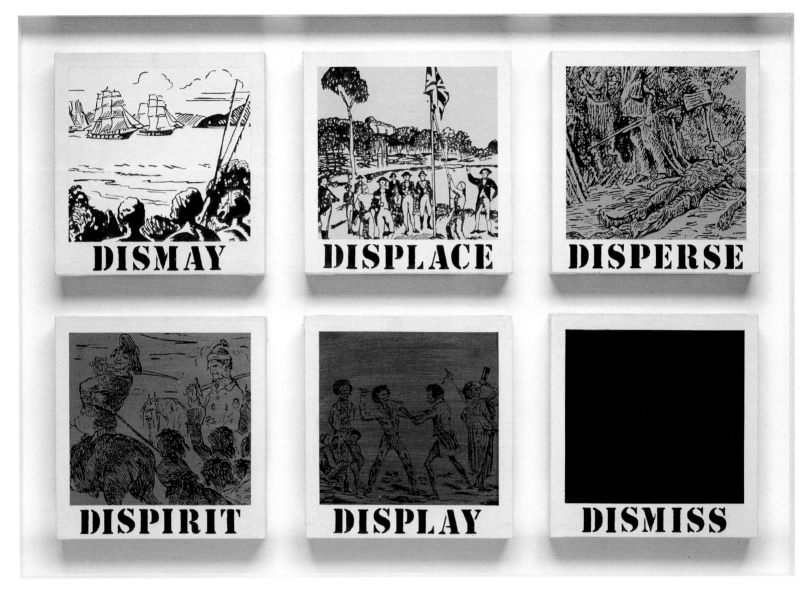

Plate 34
1989
Untitled
Six panels each 30 x 30 cm
Oil and acrylic on canvas
Collection: Museum of Contemporary
Art, Sydney
Photo: Richard Stringer

heavy with the residue of metaphysical presence; black as presence, not absence. The title 'Untitled' is a synonym for absence; the painting ironically showing the gradual foreclosure and occlusion by which a black Australia was evacuated from history. As this painting makes clear, Bennett is not just intent on replicating existing images as if such simulacra represent the postmodern condition, but he uses appropriation as an analytical tool which, by undoing the rules of representation in the first place, uncovers the staging of an ideology; and in so doing institutes a conundrum about the nature of language and being in the history of Australian colonialism.

It might seem, especially to a non-Aboriginal audience, that Bennett's first appropriations were primarily a means of picturing a culture of complaint — a culture which only feeds on its own guilt and counter-recriminations. However, these were only Bennett's first experiments

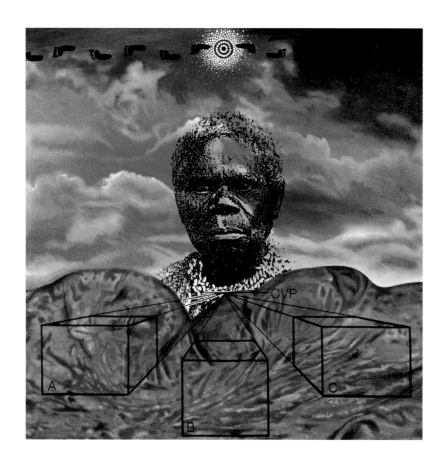

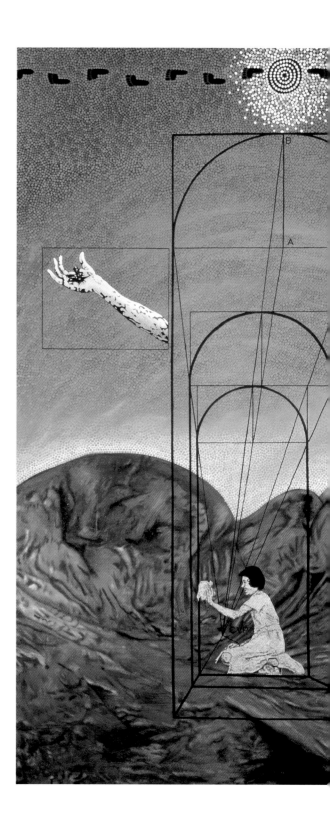

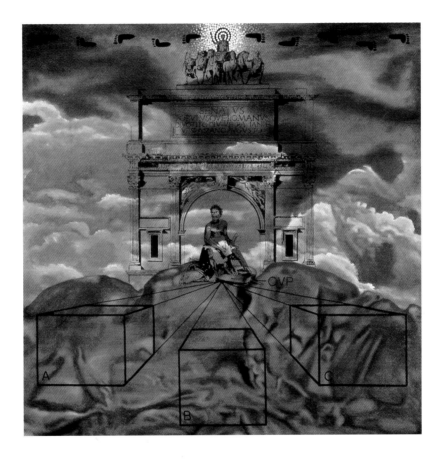

Plates 35, 36, 37
1989
Far Left: *Triptych (Detail: Requiem)*, 120 x 120 cm, oil on canvas
Centre: *Triptych (Detail: Of Grandeur)*, 200 x 150 cm, oil and photograph on canvas
Above: *Triptych (Detail: Empire)*, 120 x 120 cm, oil on canvas
Collection: Queensland Art Gallery
Photos: Courtesy Queensland Art Gallery

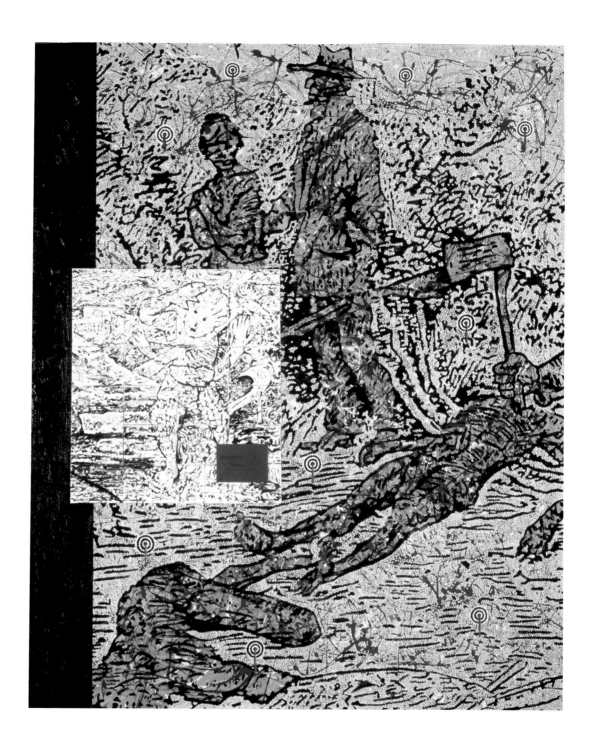

Plate 38
1990
The Nine Ricochets
(Fall Down Black Fella, Jump Up While Fella)
220 x 182 cm
Oil and acrylic on canvas and canvas boards
Collection: Private
Photo: Phillip Andrews

with appropriation, and he quickly made more of it. After all, Echo's mimicry had not stilled her desire. Because appropriation severed images from their origin, Bennett was free to juxtapose them in new and even intimate relations, to re-read and re-contextualise their original intent.

Bennett's originality lies not in his uncovering of the language structures which comprise Western art, but the uses to which he put his knowledge. If, on the one hand, Bennett's appropriations expose the ideologies at work in Western art by severing the content of its images from the structures which orchestrate this content, at a deeper level he rearticulates his

appropriations into another system of meaning — here one which lends presence to that which has been repressed by the order of Western picture making in non-Aboriginal Australian art. For example, in *Triptych — Requiem, of Grandeur, Empire* (January 1989), the two language systems of Western perspective and Papunya signage each have their own centre clearly represented, between which the eyes of Truganini stare back at us, like a ghost from a mirror. Here Truganini is a doubled icon: this much reproduced image of her being an emblem of legitimacy for the Pallawah people (contemporary Tasmanian Aborigines) and also for the new regime. For the Pallawah people it was a genealogical cipher. However, for the new regime this photograph became the emblem of the last Tasmanian, a token of death and loss. But from behind Bennett's quintessential Australian landscape of intestinal red earth (which the perspective grid and Papunya signage centre differently), looms the haunting face of Truganini which refuses to be exorcised.[15] Her face is our mirror (or ours in the mirror), the face of Echo repressed in the glassy pool into which we, Narcissus-like, stare.

Appropriation has not been an easy road for Bennett to follow, if only because it is such a vexed issue amongst colonised people. Appropriation after all, is the currency of imperialism, and Bennett did, at first find it difficult to avoid the appropriation of an Aboriginal design.[16] For example, in his student painting the *Perpetual Motion Machine* (December 1987 – February 1988), he represented a Mimi figure whose design belonged to the Central Arnhemland artist Guningbal. After receiving considerable flak from the traditional owners of the former design, in June 1989 Bennett visited Maningrida, where he apologised for his appropriation. 'I won't', he said later, 'be appropriating any more Aboriginal images because I now more fully understand the situation'. Yet, he continued, 'you have to understand my position of having no designs or images or stories on which to draw to assert my Aboriginality. In just three generations that heritage has been lost to me'.[17] But, as Bennett soon realised, this was a poor excuse.[18] It did not justify his appropriation of Aboriginal art, it misrepresented his own aesthetic aspirations, and was not the reason for his initial appropriation. Furthermore, Bennett's own work demonstrates that there are plenty of images with which to explore Aboriginality. As his paintings proclaim, Aboriginality consists of continuously developing ideologies that are embedded in the history of Australia.

If some artists have experienced Arnhem Land as a return, a coming home, Bennett was a suburban boy in culture shock. The lesson he learnt at Maningrida was that here he was also an outsider. But the visit did enable him to fully appreciate the extent of the differences which non-Aboriginal Australian culture has covered over, the plurality of what being a person of Aboriginal descent means, and thus the importance of his own subject position. This is apparent

in the paintings completed after his return from Maningrida. In the *Perpetual Motion Machine*, Bennett had painted the ancestor figures of a particular people, but not his own ancestor figures. Returning home after visiting Maningrida, he included two images in his painting *Ancestor Figures*, (September 1989) (Plate 4, p. 14): his Aboriginal grandmother, and a white angel found in a cemetery. He made a similar, if more ironic statement, in his large canvas *Self Portrait (But I Always Wanted To Be One Of The Good Guys)*, (October 1990), where he again asserts the impossibility of a single resolved identity. Dressed as a boy in his cowboy suit, he assumes the ambivalent posture of a black cowboy. 'I am', he inscribes on the canvas, 'light' and 'dark'.

This too, is the lesson of *The Nine Ricochets (Fall Down Black Fella, Jump Up White Fella)* (February 1990) (which appropriated Tillers' *Pataphysical Man* (1984) and referred to *The Nine Shots* (1985) — in which Tillers had appropriated paintings by Baselitz (*Forward Wind*, 1966) and Michael Nelson Tjakamarra's (*Five Dreamings* [1984]). In *The Nine Ricochets (Fall Down Black Fella, Jump Up White Fella)*, which won him the Moët & Chandon prize, Bennett not only parodies Tillers' appropriation of Aboriginal art as a type of colonisation (which all appropriation is), but paradoxically reinvents Aboriginality as an ideology in which the will to re-appropriate empowers. On one level Bennett seems to be doing a Tillers to Tillers, a simulacrum of a simulacrum — even to the point of emulating the flat disembodied space of Tillers' paintings. But Bennett is Echo mimicking Tillers' narcissism. Even in his most postmodern works, Bennett points to a different order. Unlike the straight shots travelling directly to their vanishing points, ricochets map a curved dangerous space — here the paths of this ricocheting space being traced by the all-over drip technique of Jackson Pollock. Appropriation, Bennett seems to be saying, is uncanny. To begin with, the original is liable to ricochet back onto the appropriator. Despite the absence of origin instituted by the simulacrum, this origin is not easily foreclosed. Instead there is always an unaccounted surplus, as if the original shadows or haunts the appropriation. At the heart of appropriation is a conundrum, symbolised by the impossible red rectangular figure near the centre of the painting. If Tillers' *The Nine Shots* is a simulacrum which silences Baselitz's screams, entombing them in the deathly realm of the commodity, Bennett's *The Nine Ricochets (Fall Down Black Fella, Jump Up White Fella)* proposes a conundrum, the conundrum of the White history of a Black people, and indeed, of his own subjecthood.

Towards An Australian Postcolonial Art

Colonialist ideology has so upset the ethical basis of subjecthood that the subject and its arrangements of identity and genealogies are on the verge of collapse. The vanguard of this new post-subjectivity are the subaltern and indigenous peoples who, through colonialism, were made strangers in their own homes. If their only compensation was the promise of a new home offered by a postcolonial future, this promise, Homi Bhabha observed, is never fulfilled. The postcolonial home remains unhomed.[1]

Coloniality plunges migrants and indigenous populations into the same undifferentiated space of loss from which they must refigure their identities. In colonial societies all parties, indigenous, settler and diasporic, eventually become supplementary to an origin or home which no longer exists. This experience of loss also overtook the colonisers when an alienating modernity transformed Europe's former centres into the frontier zones of collapsed differences we call postmodernity. In this sense, the effects of European colonialism, which are five hundred years old, appear quintessentially postmodernist. Even the economic and political strategies of colonialism — appropriation and colonisation — have become the aesthetic devices of postmodernism. Thus it might seem that we are all in the same boat. Unhinged from our histories and traditions by the deluge of coloniality and modernity, we, like Noah in his ark, herald new genealogies that take no account of previous differences.

If the cultural differences which once meant so much in discourses of identity are now dissolving into a tolerant shadowless multicultural regime of globalised cultural diversity that threatens the very concept of indigenity, what has become of difference, of the Other? To all appearances, it has been negated, leaving a world which, says Meaghan Morris, is 'shadowless, depthless, invasive'.[2] Even the genealogies and histories which once nourished our sense of self have, relates Morris, been substituted by what Fredric Jameson called 'pop history' — a flat disembodied post-history, like those period dramas which imagine the past and future, the here and there, as so many simulacra of Hollywood.[3]

If the stereotypes of pop history are the limits of today's historical imagination, Gordon

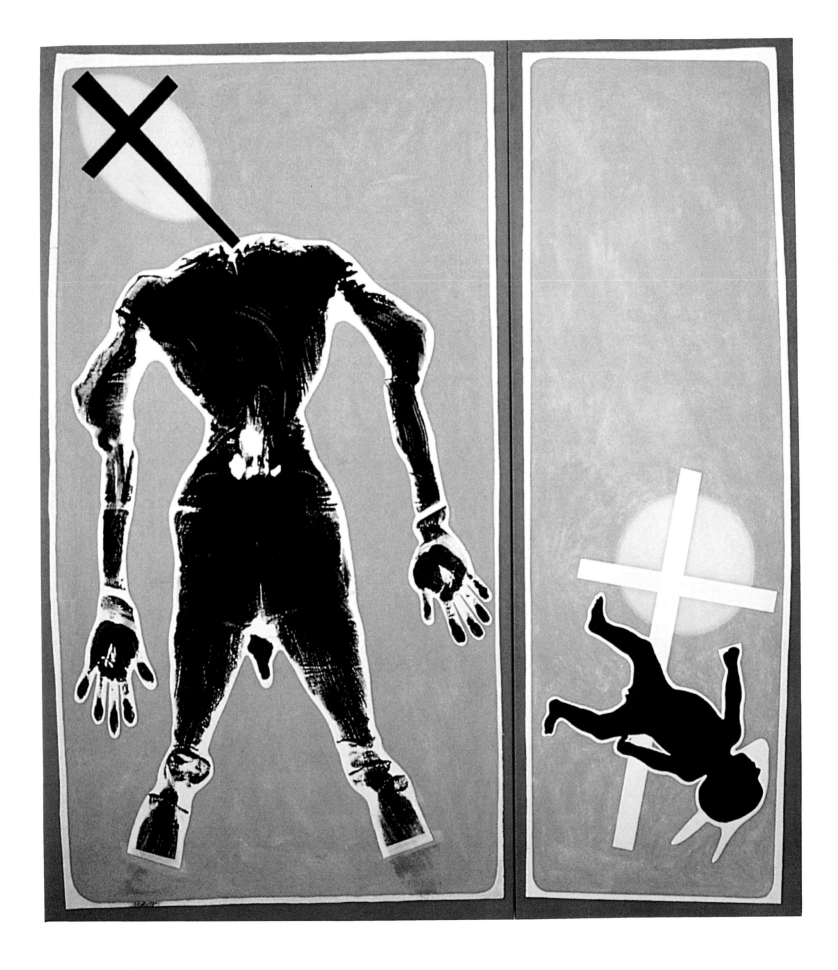

Bennett takes these limits as a starting point to be exceeded — or in Morris' words (about her own work), 'as a point of departure for asking questions' that will trace the 'shadows on the landscape' of Australia's pop history.[4] Bennett's strategy for picturing such shadows is to locate difference in the midst of postmodernist indifference. In his computer enhanced video *Performance with Object for the Expiation of Guilt (Apple Premiere Mix)* (1995) (Plate 41, p. 105), the postcolonial 'self' is represented in the dissolving image of his own body being pursued by its shadow, and surrounded by a barrage of slogans that exemplify the pop history of Australian colonialism. If, like postmodernism, the shifting space of this work elevates liminality, loss and contingency to an ontology, it also challenges the a-moral turn of postmodern (post)subjectivity by locating the fractured postcolonial 'self' in a genealogy of colonial semiologies. By unpacking the binary patterns or differences of these semiologies, Bennett hopes to return to the politics of otherness enacted by colonialism.

Bennett eschews those postmodernist mythologies of subversion and transcendence that aim to start again without history, for the more pragmatic purpose of staying in the game, of negotiating not negating positions.[5] The difference is an ethical one, and one that locates his hybrid aesthetic in the syncretic practices of subaltern colonial cultures (which used collage and appropriation as a strategy of translation well before it found a place in Western [post]modernism). While modernist collage and postmodernist appropriation aim to decentre the subject through a politics of simultaneity (de-historicised meaning) and negation (of origins), the colonised subject is already decentred, already an object of negation. Bennett commented on his own experience:

> I was socialised to believe that the [Eurocentric] "I" . . . included me, totally. When I discovered my Aboriginal descent I first denied it and repressed it. When the repression became unbearable, and that was a true decentring, not a matter of "failed locality" [Tillers] but almost of my entire system of belief — I mean a psychic rupturing.[6]

For subaltern communities, a collaged hybrid subjectivity is an everyday means of survival which negotiates and centres decentred subject positions. It is literally a means of making an identity by juxtaposing and crossing over the differences of an excess of roots, rather than, as in (post)modernism, a symbolic means of transforming an excess of roots into a rootlessness, into a negation or loss which might clear the ground for a new future. Because of their very subalternity, colonised artists do not lose sight of their strategic improvisations of identity and contingent dialogues with history. The disjuncture of subaltern collage engages its own textuality. However, the appropriations of postmodernism map a mythology of social authority

Opposite:
Figure 38
1994
Altered Body Print (Purity of Hybrids)
183 x 162 cm
Acrylic on canvas
Courtesy Bellas and Sutton Galleries
Photo: Gordon Bennett

at the supposed terminal point or end of history, in which other times and spaces are negated in order to secure the rule of contemporary privilege.

The ethics of postcolonial and postmodern collage hinge on the agency each accords to the self and the Other. Jameson has shown how the hybrid contingencies of life in late capitalism lends itself to an ethics of indifference, of an absence of the Other, which is no ethics at all. Here difference is so pervasive that its repetitions perversely create a culture of sameness in which subjectivity becomes oceanic, structurally void and so without agency. There is diversity without difference, pastiche without parody. Binaries disappear, shadows dissolve. However, like shadows cast by a full moon, Bennett's Aboriginal genealogy constantly crosses his path. Thus his art is not a simple story of one side against the other (as is most colonial discourses), or of the collapse of one into the other (as with postmodernism) but of the haunting of difference (or the Other) in identity.

Bennett's art reminds us that despite an undifferentiated globalised postmodernity, the loss experienced by indigenous populations was not only very different to that of settlers and migrants, but it is put to different purposes in the mythologies of colonialism. In the eighteenth, nineteenth and twentieth centuries migrants came to Australia for a new and better life which, for most, meant leaving behind their former homes and mainly subaltern lives forever. This loss was psychically displaced onto indigenous populations, with colonialist homeliness being brokered on the loss of the place's Aboriginality. Thus Australia was imagined as a clean slate upon which a new white indigenity or home could be planned. Not only were Aborigines made to bear the price of the migrant's psychic loss of place, but the whole process narrated a mythology which transformed negation, both the relative negations of migrantology and the absolute negation of racial genocide, into a mechanism of identity. Thus, to the English colonisers, colonialism was a modernism: a deluge that washed all before it, and, at the same time, the baptism of a new society.

If the loss experienced by migrants and indigenous groups can not be conflated, their losses were framed by the same coloniality. There are differences and commonalities. Because postmodernism pictures the effects of coloniality and modernity from one side (only), the relationship between Bennett's art and postmodernism is ambiguous not antagonistic. Historically, postmodernism is a legacy of the disillusionment and disenchantment with the redemption promised by the project of Enlightenment and progress. Bennett too is sceptical of such redemptive histories. But if he is fond of representing history by the redemptive figure of an angel, it is a black angel which lives outside the guarantees of God's realm. Nevertheless Bennett pictures an angelic space, a space of mediation between two worlds — in fact one

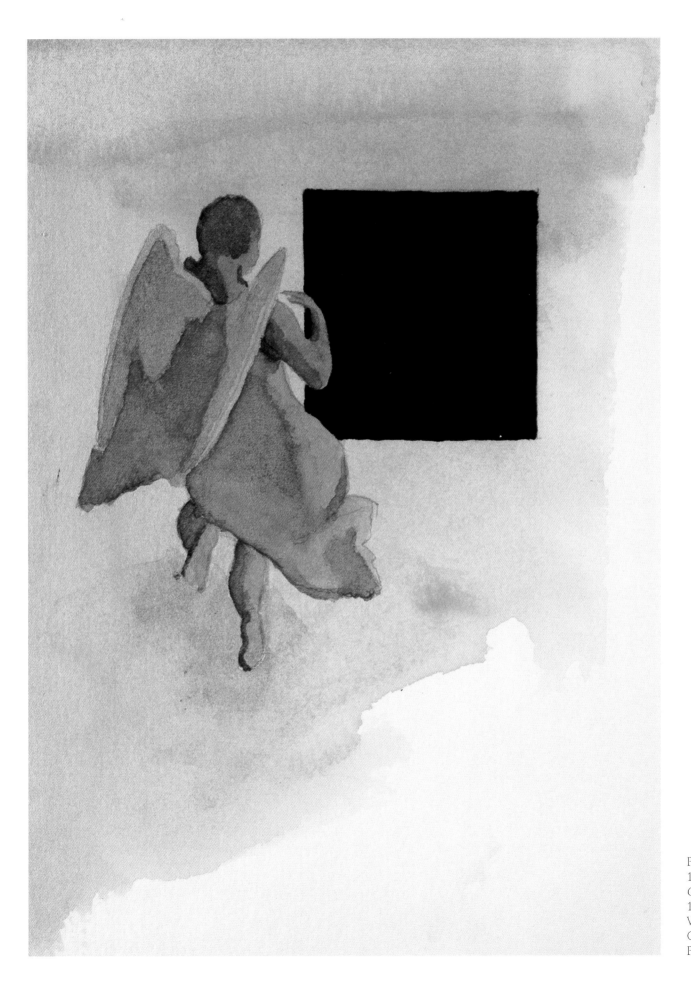

Plate 39
1993
Contemplation
14.5 x 10.5 cm
Watercolour on paper
Collection: The Artist
Photo: Kenneth Pleban

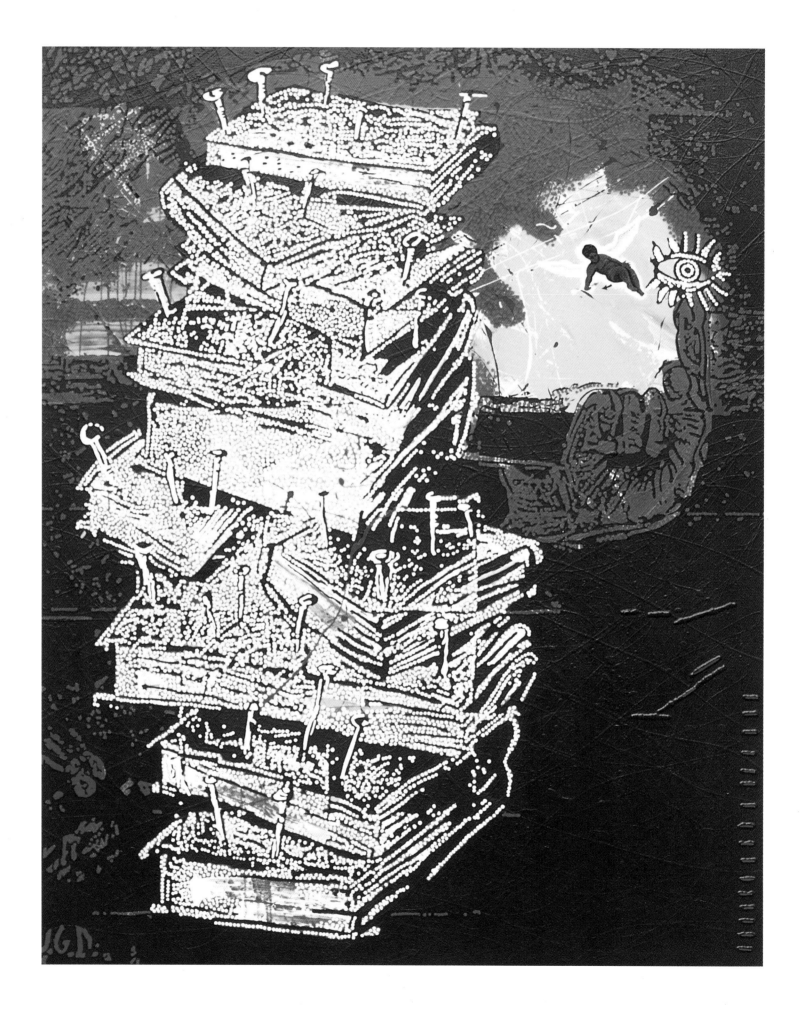

world split by the history of colonialism. In *Contemplation* (February 1993), a black angel pays homage to (draws strength from) Malevich's mysterious black square — which for Bennett is emblematic of the black absence repressed in Euro-Australian discourses.[7] The mediation Bennett seeks is within a subject divided by its own repressions, and not, as has been usual in non-Aboriginal Australian culture, within a politics of loss in which Australia is a land of reproductions, of second hand images. For example, the exemplary Australian postmodernist artist, Imants Tillers, pictures an Australia (indeed a world) without a centre; an homogenised world where everything is, as in death, 'equivalent, interchangeable, scale-less and surface-less'.[8] He presumes the impossibility of an identity politics, let alone a meaningful reconciliation between black and white cultures. Bennett demands this impossibility. If Bennett has some sympathy for Tillers' diagnosis, he contests his prognosis.[9] Thus while continually proclaiming the impossibility of a centred self within the frame of Australian colonialism, Bennett does not repudiate the quest.

Bennett is, of course, fully aware of his ambiguous relationship with postmodernism, and sometimes consciously addresses it in his paintings, especially those which refer to the works of Tillers. In *The Recentred Self* (February 1994), an appropriation of Tillers' *The Decentred Self* (1985), Bennett shifts the politics of identity from that of loss to one of difference. Instead of Tillers' grey world is one of colour, both literally and metaphorically. It is as if Bennett imagined what sort of painting Tillers might paint if he was of Aboriginal descent. *The Recentred Self* looks more or less similar to Tillers' *The Decentred Self*, except that it includes Bennett's trademark black Pollock ground with etched red welts (discussed below), dot painting, the colours of the Aboriginal flag and a black angel. The angel recalls Bennett's first depiction of black angelic figures in *Resurrection (Bloom)* (October 1990), in which two black *putti* remove the arrows from their chest underneath the blooming of a giant yellow flower/sun of the Aboriginal flag which, like a talisman, is an omen of hope and a recentred identity. However the recentring remains a promise, a distant vision, perhaps a mirage, even a fool's promise. If, like Joseph Beuys, Bennett aspires to certain shamanistic practices which might heal a decentred society, he eschews the arrogance of such a stance. The redemption Bennett reaches for is clouded with irony. But it is an irony which, for Bennett, is the sign of subjecthood; the irony of a subject divided against itself.

If, during the years immediately after leaving art school, Bennett adopted a postmodernist aesthetic, in more recent years he has more consciously pictured the metaphysics of identity for the postcolonial subject. In many respects this has meant a return to the metaphysical and existential interests of his student work. This return can be traced to the time spent in France

Plate 40
1994
The Recentred Self
167 x 137 cm
Acrylic on linen
Collection: The Artist
Photo: Phillip Andrews

during his Moët & Chandon residency, between July 1991 and June 1992 — though the first signs of this shift are evident immediately prior to his departure for France.

It is a commonplace that the distance of exile, or even just a trip abroad, causes the subject to reflect on his or her own being, identity and place. Thus one could speculate on the psychology and irony of being an artist of Aboriginal descent living in France. The first Aborigines brought to France were the subjects of experiments by physical anthropologists; their brains and bodies measured and dissected. Now Bennett was being brought here, and he too was being watched. Is this why Bennett returned the gaze? Refusing to act out the exotic rituals of a colonial exhibit, Bennett turned his eyes on the indigenous European art of the existential generation framed by the apocalypse of war — art by Yves Klein, Fontana, Broodthaers, Sigmar Polke, Baselitz.

Bennett also made a close study of the pre-eminent post-war US artist, Jackson Pollock, having first used Pollock's drip style in the painting which took him to France: *The Nine Ricochets (Fall Down Black Fella, Jump Up White Fella)*. If perspective was invented by Brunelleschi when Europe was beginning its colonial adventure, Pollock painted his drip paintings when Europe's old empires were being eclipsed by anti-colonial revolutions. Again, Bennett instinctively drew parallels between the icons of an age and its larger social, political and economic history. If Pollock understood the space of his paintings as a pictorial chaos that he had to order, Bennett's mobilises it as a symbolic space: its arabesque in-betweenness signifying the curved space of postcolonial identities that contest the rectilinear perspectival space that grounded the colonialist order of Enlightenment.

Bennett was also attracted to the inherent violence and fetishistic implications of Pollock's method. The whipping action which layered paint onto the canvas emulated the horror and grotesquerie by which colonialism claimed Australia. In February 1992 Bennett made his first welt pictures, in which Pollock's dripping is consciously crossed with a whipping action. The welts break the surface of the paint, causing the canvas to 'bleed'. However, in making the canvas an apocalyptic site, Bennett also made it a redemptive space. This is self-evident in *Performance with Object for the Expiation of Guilt*, a performance video piece first made in February 1994, and re-edited in January 1995 as *Performance with Object for the Expiation of Guilt (Apple Premiere Mix)*. Bennett performs dressed in a black suit, his face wrapped in a white bandage like the invisible man, whipping a black box built to the dimensions of his own body, abusing it with racist words. On one level the whip is a simile for the violent gaze of Western metaphysics and its language of binary enclosures. But Bennett's fetishistic ritual of sacrifice and atonement renders ambiguous the binary relations of subject and object that such exercises usually imply.

Plate 41
1995
Performance with Object for the Expiation of Guilt (Apple Premiere Mix)
Detail of video still
Courtesy Bellas and Sutton Galleries
Photo: Gordon Bennett

Instead of collapsing these binary relations into an arena of cultural diversity, Bennett maps a space of difference into which he falls. As his self paces between its constitutive parts of invisible body and its alter-forms of box and shadow, the shadow mimics his every move, returning his objectifying abuse to its origin in the politics of otherness.

At the same time that Bennett expanded his Pollockian iconography, he further developed his previous interest in mirrors. In many ways the space created by Pollock's all-over drips emulated the space of the mirror which Bennett had previously found useful as a fetish of identity and redemption. The aura of the mirror, its curved space and reflective sheen, provides an ideal virtuality for fetishisation. In the mirror anything is possible because nothing is there. Pollock's all-over drips are like the tain of the mirror; and in their curved space viewers have discovered all manner of monsters and gods. Moreover, the iconic status of Pollock's paintings have made them modern-day fetishes, with many artists drawing on his aesthetic to empower their own practice.

Plate 42
1991
Interior (Abstract Eye)
185 x 185 cm, oil on canvas
Collection: Moët et Chandon, France
Photo: Courtesy Moët et Chandon, France

Plate 43
1991
Abstract Mirror
185 x 185 cm, oil on canvas
Collection: Private
Photo: Richard Stringer

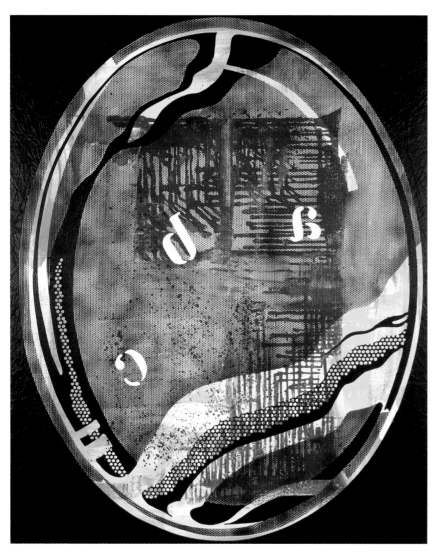

Plate 44
1994
Mirror (Abstract Field)
167 x 137 cm
Acrylic on canvas
Collection: Private
Photo: Kenneth Pleban

Bennett had always been interested in the iconic power of fetishes, even if it was only to deconstruct them. For example, in *Australian Icon (Notes on Perception No. 1)* (March 1989) (Figure 19, p. 39), Bennett joins two famous fetishised images in Australian lore, that of Captain Cook and 'One Pound Jimmy', the archetypal 'noble Aborigine' whose image first appeared on the front cover of the travel journal *Walkabout* in September 1950, and later on stamps and numerous other artefacts. Bennett got his image from a beer coaster found in a Brisbane pub with a reputation for racist practices. No doubt images of Captain Cook are also reproduced on beer coasters. However, if the images of Captain Cook and 'One Pound Jimmy' have both become so ideologically laden that each was reduced to elements in a binary code of colonialism, it has usually been the fate of those like 'One Pound Jimmy', the colonised, to be completely forgotten by this ideology, their real lives foreclosed, while those like Cook, the colonisers, are redeemed by this ideology (of colonialism). How many people know the name of 'One Pound Jimmy', perhaps the most reproduced image of an Aborigine in the post-war period? While he was not initially aware of it, Bennett was later pleased to learn that 'One Pound Jimmy' is the father of Clifford Possum, thus making him more real to Bennett — for the purpose of Bennett's aesthetic was to undo the fetishisation of Aboriginality in order to release the thinking and imagining of Aboriginality from the ideological shackles of colonialism, and, at the same time, to show the extent to which Aboriginality, to this day, shadows white mythology, is its nemesis and other.[10] Thus for Bennett, the pop history exemplified by the beer coaster he found in a Brisbane pub was a sign of both another history and a possible redemption, for its fetishisation cut both ways, locking Aboriginality into a white mythology and ironically reminding this mythology of its limits.

Just prior to taking up his residency in Europe, the home of colonial fetishism, Bennett's work began to show an interest in the ontology as well as the effects of fetishisation. Besides deconstructing the fetishised images of colonialism, Bennett also turned the fetishistic power of art against colonialist ideology. Just prior to embarking for France, Bennett became interested in

the power of the fetish to both redeem and condemn, and his aesthetic strategy shifted towards a more iconic mode reminiscent of his earlier work. In effect, he reinstated the power of fetishism that was evident in his student work. If at first *Interior (Abstract Eye)* (March 1991) and *Abstract Mirror* (March 1991) seem in the vein of *Web of Attrition* (1989) (Plate 8, p. 22), the insertion of the eye and the Lichtenstein mirror in the upper left hand corners radically alters the reception of the images. These insertions, like the proverbial eye of Christ, follow the viewer around the room. Like a fetish, or an icon, they hold the subject in their gaze. Ironically, and perhaps disturbing in the context of Bennett's aim, *Interior (Abstract Eye)* was purchased by Moët & Chandon and went to France, while *Abstract Mirror* stayed in Australia. Europe remained the home of the eye; Australia was still a mirror-world!

Bennett's renewed interest in the ontology of fetishism is also evident in his use of colour. In the years prior to winning the Moët & Chandon prize, Bennett's colours were generally subdued, often ochres and mono-tonal. However just prior to travelling to France his colours become more highly keyed, as in the painting *Bounty Hunters* (April 1991) (Plate 23, p. 51). If it again depicts a brutal narrative of colonialism, the bright colours, the grided curtain of bright red crosses and the refracted light of the watercolour, lend the picture an iconic status. Like gothic pictures of martyred saints and tortured Christs, the horror of the scene is the gateway to a more abstract religious state of atonement. The ambiguity of rendering massacres in an iconic mode creates a psychically disturbing atmosphere not seen in Bennett's work since the *Outsider*.[11]

If *Bounty Hunters* recalls an earlier metaphysical phase, Bennett has not dispensed with his deconstructive aesthetic. The narrative element remains, and the aura of heightened colour is undercut by a certain garishness reminiscent of Pop art. Pop artists are also interested in icons, but their icons are the grotesque fetishes of everyday modernity. Pop art jokingly deconstructs its own fetishistic pretensions. Bennett first consciously signalled his interest in Pop Art with his appropriation of Lichtenstein's *Mirror No 6* (1971) in *Abstract Mirror*, (1991). By 1994 Bennett had renewed his interested in the significance of mirrors, and developed the image of the Lichtenstein mirror into an ongoing series, such as *Mirror (Harlequin)* (August 1994), *Mirror (Abstract Field)* (August 1994), *Mirror (Altered Body Print: Dismember/Remember)* (September 1994). However, whereas Lichtenstein's mirror is always empty, Bennett interpreted this absence to signify what is occluded in Western art and its pop historiography (comic book story) of

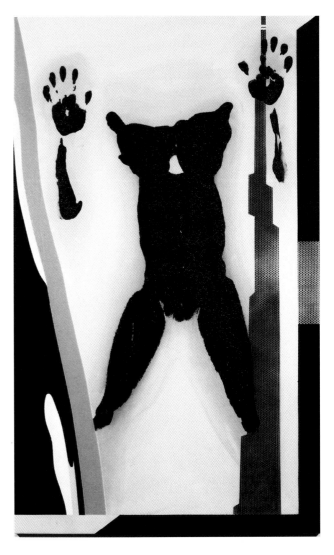

Figure 39
1994
Mirror (Altered Body Print: Dismember/ Remember 2)
167 x 101 cm
Acrylic on canvas
Collection: Private
Photo: Kenneth Pleban

Plate 45
1994
Painting for a New Republic (The Inland Sea)
232 x 507 cm
Acrylic on canvas
Collection: Art Gallery of Western
Australia
Photo: Kenneth Pleban

Aboriginality. Bennett populates his Lichtenstein mirrors with the ghosts of colonialism. Nowhere was the purpose of this aesthetic and the politics of identity it expounded more fully worked out than in the large *Painting for a New Republic (the Inland Sea)*, painted in August 1994.

In *Painting for a New Republic (the Inland Sea)*, Bennett pictures the history of Australia as a grand moral scenography. However, despite the scale and baroque choreography of the set, there is no clear narrative. Its monumental vision might even be a self-portrait rather than historiography, showing Bennett's own interior sea, the curved space of his mind as he looks out through his left eye to a mirror reflecting his visage, and, perhaps, reflecting on Paul Carter's observation that 'the strangest place in this looking glass world [of colonialist representations] is where we stand, looking into it but fail to see ourselves mirrored there, glimpsing instead the strangeness of our origins'.[12] Or is this painting a screen of the Australian imaginary? Whatever,

the scene is filled with differences rather than the empty desert which Baudrillard, for example, imagined colonised spaces such as America to be.[13] On the left side are the relics of colonialism: the British flag, memories of exploration and massacres, even a white obelisk, as if a monument to the White mythology of colonialism, all of which float on a Pollock-like ground.[14] On the other side, the right side of the painting, is the spiral perspective of what appears to be the remnants of a Western Desert ground painting. There are slippages or leaks between these orders: the ground painting emanates from near the sinking boat on the top right of the painting, while a crucified Aboriginal figure slips into the dark iconic region of skulls, bones and obelisk. The picture also cuts between inside and outside, each side haunted by the other. Inside, as if the navel of the picture, a Lichtenstein mirror is an emblem of the oval shaped eye. Into (or out of) this navel flows the mythical inland sea, carrying a floating head which is looked

at by the eye reflected in the mirror on the outside. Here is a more ordered world, consisting of a mirror in which is reflected a face, a table with a book by Kant, and, in the distance, a symmetrical tree marking the vanishing point of a centred perspectival space. If this outside bears no resemblance to the inside, its promise of a golden dawn appears like a brilliant escape from the dislocated interior.

Bennett's image of the new republic is framed by the rhetoric of history and identity, but not with the usual clear vistas of nationalism. History, he seems to be saying, cannot be foreclosed. The outside, here pictured like the sunlit enlightenment and neo-classical rigour of republican virtue which Plato and his followers assured us was outside the cave, is not offered as an escape. Rather, it is haunted by the inland sea. Bennett, then, offers no panacea for the future, only troubling questions about origins and genealogies — unanswered questions exemplified by the mysterious red and yellow heads which lie like lovers at the top of the picture — or like the disjointed reflections of the other as seen in Bennett's earlier painting *Echo and Narcissus*. It is tempting to think of these heads as self-portraits. However, if there is a passing resemblance, it is hardly conclusive. More pertinent is that both heads have a caucasian bone structure — a physiognomy which led many nineteenth century anthropologists to conclude that Aborigines were of caucasian origin. Such are the ironies of identity with which Bennett typically plays, deliberately clouding those essentialist questions of race which so often plague questions of identity. Thus the epicentre of the picture into which most of the painting drains is a figure drawn from Baselitz's painting of a white crucified figure (*The Poet*, 1965), overlaid with an image of the skeletal remains of 'Mungo man', and ornamented (shot) with the southern cross. The same hybrid cross-overs occur in Bennett's Aboriginalisation of the web-like structure of *The Poet*.

So, is this painting a self-portrait? No more than any other. In fact the pictorial origins of the two heads are straight forward. The red face is of an explorer taken from an Australian social studies book. The other is from an article in a German art magazine on perception and perspective.[15] Both are generic types preferred by illustrators: one the generic explorer, the other the generic human head, white, male, Saxon, thoughtful. If this painting is a self-portrait, it redefines the parameters of portraiture. It might be more useful to describe the painting as a portrait of the nation, though it pictures the failure of the nation to know itself, a *Volkgeist* split and unreconciled with its past. Bennett might not picture the constitution of the new republic, but he does ground its possibility in a cross-cultural imagination in which the tain of the mirror provides more than a mere reflection; it stages the postcolonial subject, the citizens of the new republic. *Painting for a New Republic (the Inland Sea)* is a self-portrait and

Figure 40
1995
Mirror (Interior / Exterior) Volkgeist
167 x 137 cm
Acrylic on canvas
Courtesy Bellas and Sutton Galleries
Photo: Sam Charlton

historiography, both modes being mutually dependent in any project of subjectivity.

Painting for a New Republic (the Inland Sea) reads, like many of Bennett's paintings, as if it is an installation. There is a physicality to the organisation of the pictorial space as if it has been assembled rather than modelled. This disjointed collaged space refuses the wholeness of presence, as if everything is fractured, doubled, partly there, partly not. This too is the main point of Bennett's interest in mirrors, for the tain of the mirror is that mesmerising frontier between absence and presence which gives the mirror its iconic power, and the images held

Plate 46
1993
Mirror Line
Mixed media
Site-specific installation
University of Melbourne
Photo: Kenneth Pleban

within their alluring palpability. Indeed the whole painting is a mirror of Australian colonial history — perhaps the tain of Australia's colonial flag which it curiously resembles, union jack in the top left corner and the southern cross in the bottom right.

The mirror is the enduring emblem of Bennett's work, and was only absent from his work during his most insistent postmodernist phase, between the second half of 1989 and early 1991. It returns, as I have indicated, during his residency in France, and today makes up the central iconography of his work. For Bennett, the reflectivity of the mirror is not the agent of postmodern simulacra, but a means of engendering the postcolonial subject. Bennett's most thorough investigation of the significance of mirrors occurred in 1993, during the making and planning of two major installations, *Mirror Line* and *Present Wall* — the former being constructed at Ian Potter Gallery at the University of Melbourne in September 1993,

and the latter being made for the Adelaide Festival in early 1994. In both installations the mirror is a curved in-between space where a new psychic (postcolonial) identity is possible.

Bennett's installation *Mirror Line* used some of the most prized works from the University of Melbourne's art collection, displaying them with such a strong narrative structure and cross-referencing that the viewer was forcibly centred around the stark binary of Aboriginal and Euro-Australias. This centring was enhanced by the management of the installation: the sculptures were on bases, the real 'Master' paintings *tastefully* framed, and everything was immaculately presented against the white walls so that, on cue, the architecture receded to stage the art. Indeed, so successful was this that Bennett's loan of these works of art can not be regarded as an appropriation, for their power as images in their own right was preserved. In *Mirror Line* they serve as quotations, not simulacra. The mirror's position on the floor as a hinge, a line dividing

Plate 47
1994
Present Wall
Mixed media
Site-specific installation
Institute Building, Adelaide
Photo: Clayton Glen

the installation in half, served as a metaphor for the nature of the binary displacements that occurred on many levels throughout the work. For example, the Aboriginal paintings mirrored the nineteenth century lithographs by settler artists of Aborigines on their land. However Bennett did not manufacture a postmodern simulacrum, but staged a psychological mirror world; the mirror line being the arabesque site of deconstruction. Having instituted a stark

binary structure in which the Aboriginal paintings, like Echo, mirrored the narcissism of the Australian colonial landscapes, the reflectivity of this hinge opened up the binary, the reflections in the mirrors on the floor re-articulating *another* parallel symmetry which exceeded the binaries of the room by suggesting new juxtapositions of objects.

Inserted into and between the binary display on the walls, the mirror on the floor becomes an inverted space in which a new subject becomes possible. Literally an illusionary well (pool) in the ground (foundation) upon which 'Australia' (the gallery) is built, the mirror opens up a panorama of grotesque events (of colonialism), what Bennett called a 'mirrorama' of continuously unfolding reflections in which images are momentarily suspended rather than fixed in time and space. This cinema unfolds a mercurial subject to its prehistory — here artefacts of a colonial past inserted into our living present. This is not simply a de-centring process. Rather Bennett not only retained the iconic remnants of colonialist discourses (eg. the nineteenth century lithographs), he polished them to give them their full effect, so that when he opened each to its other, juxtaposing them according to their acute binary formations, the mirror line shimmered with a third presence, a double reflection, a palimpsest of coloniser and colonised — the postcolonial subject. Put simply, Bennett's critical purpose is to recirculate repressed memories until the postcolonial subject becomes a possibility.

If *Mirror Line* appropriated art objects, *Present Wall* appropriated an architectural space. Here Bennett was more interested in historiology than historiography; in what might be called the being of history and its relation to language and ideology. This metaphysical concern was signalled in the over-arching binary text of *The Past/The Future* which framed the installation, each term of the binary marked by lengthy dictionary definitions. The result was an unusually abstract piece composed almost entirely of words (there are thousands).[16]

The site of the installation was a former nineteenth century newspaper reading room of colonial vintage in Adelaide's Institute Building. The reading room was a memory of a nation, and thus a place where the narrations of nation can be read and unread. Bennett returns to this former nineteenth century colonial newspaper reading room like an exorcist searching for ghosts, his instrument of exorcism being the mirror. The mirror, by making visible the opaque origin of its transparent imagery, is like the perspectival diagram (and is an instrument of perspective): it offers 'a way of exposing' or making 'visible' the ways in which history is 'constructed' by language so that 'one can start to see other ways of' constructing or writing history.[17] In *Present Wall* the mirror tiles are a door to another world; they turn the room upside down, the reflections of the room's high ceilings, large chandelier and ornate ceiling making a deep pool in the mirror tiles on the floor. Thus the ceiling is run into the floor, just as the past is

into the present. The pool's edge (frame) is the newspaper wall (a wall of words). Here (in both the reading room and its inverse *Present Wall*) the overload of language unambiguously makes it the final arbiter of history and its ideologies of identity, race and colonialism. Bennett shows that language is ideology. In this scheme, the structure of language orchestrates all those binaries that sets the self against the other, white against black, coloniser against colonised.

Postmodernist appropriation is not, as it might seem, a way of accumulating other identities, but a tactic which breaks their codes of representation so that all identities are reduced to a commodity, or fetishised objects of exchange. Philip Brophy, for example, characterised the postmodern subject articulated by Maria Kozic as 'a sensibility of *being lost* inside the terrain of mass images'. Her 'desire', said Brophy, was not to address 'something in her subject matter', but to '*become* it'. 'To use this kind of imagery, you have to lose your identity'.[18] Bennett's dilemma is very different. Already lost, already a fetishised object, his intent is to re-enter (reclaim his) history.

Tired of being fetishised, Bennett aims to become his own subject by adopting the currency of the colonised: mimicry. Mimicry, not mimesis. If in the Platonic scheme mimesis is a second hand copy of an original plenitude, Fanon has shown how, for the colonised, mimicry is a means of empowerment through irony. And this is exactly why postcolonial artists and critics are, to coin a phrase which Bhabha recuperated from colonial India, 'mimic men'. The mimic, says Bhabha, 'rearticulates presence in terms of its "otherness"', that is, as a mirrored image.[19] Bennett, living like all of us in a postmodern world, finds himself in a mirrorama rather than gazing out the open window of essentialist identities. He knows that for him there is no ethnicity to chase.[20] If his art pictures an Australian identity, it is a multi-centred one which circulates between positions, which makes from the diaspora that colonialism plunged Aborigines as well as immigrants and colonials into, a mode of being in the world. However, if the Aboriginal experience is, in this sense, an exemplary Australian and migrant one, what Aborigines have suffered as a naked oppression, Euro-Australians have experienced as an entrancing repression. The difference is the conundrum of Bennett's work, and perhaps the conundrum of what being an Australian might mean.

each man is an interior sea

and

inhabitant of a

fluid matrix.

At some point in our lives, one might suppose, we have all wanted to move forwards and have not. We have stood before the rock and counted the broken chips. We have come against the first cells and heard the endless sands. But...

we

have

not

moved.

Plate 48
1995
Im Wald (Divided Unity)
220 x 312 cm
Acrylic on canvas
Collection: Private
Photo: Sam Charlton

Footnotes

The Manifest Toe Pages 9–62

1 Bruce Elder. *Blood on the Wattle: Massacres and Maltreatment of Australian Aborigines since 1788*, Childs and Associates Publishing Pty Ltd, Sydney, 1988. p. 42.

2 Thomas McEvilley, 'Enormous Changes at the Last Minute', *Artforum*, October, 1991, p. 87.

3 M. Torgovnick, *Gone Primitive: Savage Intellects, Modern Lives*, Chicago and London 1990, p. 14.

4 Martin Stanton, *Outside the Dream: Lacan and French Styles of Psychoanalysis*, Routledge and Kegan Paul Ltd, London, 1983, p. 25.

5 John Rajchman. *Truth and Eros: Foucault, Lacan and the Question of Ethics*, New York and London, 1991, p. 101.

6 Ibid., pp. 111–112.

7 Antonio Gramsci, *The Prison Notebooks: Selections*. (Translated and edited by Quintin Hoare and Geoffrey Howell Smith) New York, International Publishers, 1971. p. 324.

8 *Community and Personal Histories*, Department of Family Services and Aboriginal and Islander Affairs. p. 3.

9 Ibid., p. 7.

10 Ibid., p. 6.

11 W. Murdoch, *The Making of Australia: An Introductory History*, Melbourne, (1917), p. 9. This was one of a series of Australian history school books written by Murdoch. The others were entitled *The Struggle for Freedom*, and *The Australian Citizen*. The first chapter of *The Making of Australia* is called 'The Unknown Continent', and facing the title page is a drawing of Cook landing at Botany Bay and raising the British flag.

12 Ian McLean, 'Colonials Kill Artfully', *Papers on Academic Art: Papers of the Art Association of Australia*. Vol. 3, edited by Paul Duro, Canberra, 1991, p. 60.

13 Martin Stanton, *Outside the Dream: Lacan and French Styles of Psychoanalysis*, Routledge and Kegan Paul Ltd, London, 1983, p. 2.

14 Ibid., p. 1.

15 Lucy Lippard, *Mixed Blessings: New Art in a Multicultural America*. Pantheon Books, New York, 1990, p. 43. see also — Adrian Piper, 'Flying', in Adrian Piper. New York: Alternative Museum, 1987, pp. 23–24.

16 Frantz Fanon, 'On National Culture', in *The Wretched of the Earth*, London, 1963, p. 170.

17 Stephen Mueke, 'Lonely Representations', *Power, Knowledge and Aborigines* edited by Bain Attwood and John Arnold, La Trobe University Press in association with the National Centre for Australian Studies, Monash University, 1992, p.42.

18 Fanon, p. 170.

19 Bain Attwood, in the introduction to; *Power, Knowledge and Aborigines* edited by Bain Attwood and John Arnold, La Trobe University Press in association with the National Centre for Australian Studies, Monash University, 1992, p. ii.

20 Bain Attwood, p. xi.

21 Gillian Cowlishaw, 'Studying Aborigines', *Power, Knowledge and Aborigines* edited by Bain Attwood and John Arnold, La Trobe University Press in association with the National Centre for Australian Studies, Monash University, 1992, p. 24.

22 Gillian Cowlishaw, p. 25.

23 Stephen Mueke, p. 40.

24 Stuart Hall, 'Cultural Identity and Diaspora', *Identity: Community, Culture, Difference*; edited by Jonathan Rutherford, Lawrence and Wishart, London, 1990, p. 226.

25 Ibid., p. 225.

26 Phillip Thompson, *The Critical Idiom: The Grotesque*. London, Methuen and Co Ltd, 1972, p. 13.

27 Lucy Lippard, pp. 199–242. (Irony, humour, and subversion are the most common guises and disguises of those artists leaping out of the melting pot into the fire. They hold up mirrors to the dominant culture, slyly infiltrating mainstream art with alternative experiences — inverse, reverse, perverse. These strategies are forms of tricksterism, or 'Ni Go Tlunh A Doh Ka' — Cherokee for 'We Are Always Turning Around . . . On Purpose' — the title of a 1986 travelling exhibition of American artists organised by Jimmie Durham and Jean Fisher. Those who 'are always turning around on purpose' are deliberately moving targets, subverting and 'making light of' the ponderous mechanisms set up to 'keep them in their place'.)

28 Henry Reynolds, *The Other Side of the Frontier: Aboriginal Resistance to the European Invasion of Australia*. Penguin Books, Australia, 1982.

29 Henry Reynolds, *With The White People: The Crucial Role of Aborigines in the Exploration and Development of Australia*. Penguin Books, Australia, 1990.

30 Stuart Hall, p. 225.

31 W.J.T. Mitchell, 'The Pictorial Turn', *Artforum*, vol 30 (no.3) 1992, p. 91; in referring to the 1924 essay 'Perspective as Symbolic Form' by Erwin Panofsky.

32 D. Preziosi, *Rethinking Art History: Meditations on a Coy Science*, New Haven and London, 1989, p. 66.

33 Ibid,. p. 68.

34 Ibid,. p. 97.

35 Ibid,. p. 98.

36 Ibid,. p. 49.

37 Peter Sutton, *Dreamings: The Art of Aboriginal Australia*, Exhibition Catalogue, Penguin, Ringwood,

Australia, 1988, p. 84.

38 Ibid,. p. 91.

39 Ibid,. p. 18.

40 The term 'psychotopographical' I found in a text that I have since been unable to relocate. It was referred to as a now 'discredited' concept which to me seemed to be a perfect irony. It felt right to use this 'discredited' term as a title for paintings that were exploring a Eurocentric perspective.

41 Thomas McEvilley, 'On the Manner of Addressing Clouds', *Art and Discontent: Theory at the Millennium*, McPherson and Company, New York, 1991, p. 81.

42 *The Macquarie Dictionary*, The Macquarie Library, Macquarie University, New South Wales, 1991, p. 1402.

43 *Psychology Today: An Introduction*, CRM Books, Del Mar, California, 1972, p. 729.

44 Thomas McEvilley, 'Father the Void', *Art and Discontent: Theory at the Millennium*, McPherson and Company, New York, 1991, p. 171.

45 Ibid,. p. 170.

46 Thomas McEvilley, 'Art History or Sacred History?', *Art and Discontent: Theory at the Millennium*, McPherson and Company, New York, 1991, p. 149.

47 Bain Attwood, in the introduction to *Power, Knowledge and Aborigines* edited by Bain Attwood and John Arnold, La Trobe University Press in association with the National Centre for Australian Studies, Monash University, 1992, p. ix.

48 Adam Kuper, *The Invention of Primitive Society: Transformations of an Illusion*, Routledge, London, 1988, p. 7.

49 Albert Boime, 'The Revulsion to Cruelty', *The Art of Exclusion: Representing Blacks in the Nineteenth Century*, Thames and Hudson, London, 1990, p. 75.

50 Bain Attwood, p. iii.

51 Henry Reynolds, 'Conclusion', *The Other Side of the Frontier*, Penguin Books, Australia, 1982, p. 199.

52 Political Correctness and anti-Political Correctness are two sides of the same coin. Both tend towards censorship of language that may give offence to, on the one hand so-called 'minorities', and on the other to the so-called 'mainstream' (read 'white' backlash). Either way dissent is punishable by censorship. With the anti-Political Correctness lobby in defence of the old order of things, claiming constriction of 'free speech' as their moral platform, and clouding real issues of inclusion and empowerment by turning any debate into a debate on Political Correctness per se. Is the term 'peaceful settlement' as opposed to 'invasion' any less a 'sensitive phrase' than 'differently abled' is to 'cripple' or 'ethnic cleansing' is to 'genocide'? The trouble with the fiction of free speech is that so-called 'minorities' don't have much access to the mass media, and do not generally have the 'right of reply' to offensive or racist cultural commentary that the idea of free speech might imply. When issues are reported in the media it is usually by a member of the 'mainstream', to a presumed 'mainstream' audience, and framed within the perspectives and cultural prejudices of the 'mainstream'. The fact is that there are no Aborigines with a regular 'opinion' column in our newspapers, but there is a surplus of non-Aboriginal commentators only too willing to censure those views and criticism of 'white'

myths they feel offended by. Mark O'Connor, in his argument against the term 'invasion' in the
Courier Mail of February 1994, said that: 'Aborigines may well be offended by talk of their homelands
being "discovered" by others; but they do not have the right to ban the term'. And with that the
argument was turned to a debate about Political Correctness and censorship. My point is that for the
Queensland Government to pulp year five readers that used the term 'invasion', and for 'mainstream'
commentators to so thoroughly denounce the term — and the different perspective it supports in a
land of free speech — in such a vehement way is most certainly censorship of the very kind the anti-
Politically Correct lobby decries. O'Connor describes a politically correct state as one where: '. . .
dissent is punished — whether by jail, or more subtly by ostracism or denial of promotion — until
officially approved views prevail' (my italics). Sounds like an Aboriginal, and other 'minority', experience
to me. I don't consider my work as 'politically correct' in any sense of the term and I reject the
reductive, polarised and artificial binary space the semantics of the argument, and the argument over
semantics, enforces. I would argue my position as searching for a balance and would place myself in
the space between 'oppositional' cultural politics. Not a 'fence sitter', which is a term relevant only to
a simplistic binary framework, but an agitator for a holistic world view that can experience the world
from multiple perspectives, from a position of empathy and ethics, an 'aesthetic' of rethinking the
ancient question of 'ethos'. John Rajchman, in his book *Truth and Eros: Foucault, Lacan, and the Question
of Ethics* (p. 124), describes Ethos as: how to be 'at home' in a world where our identity is not given,
our being-together in question, our destiny contingent or uncertain: the world of the violence of our
own self-constitution.

53 Jacques Le Goff, 'Preface', *History and Memory,* Columbia University Press, New York, 1992, p. xi.

54 Daniel Thomas, 'Land versus People', *Antipodean Currents: Ten Contemporary Artists from Australia,*
 Catalogue, Guggenheim Museum Publications, 1995, New York, p. 36. While I respect Daniel
 Thomas and believe that this comment was made with no racist intentions, I nevertheless feel that this
 gross kind of reductionism misrepresents all of the artists concerned.

55 Frank Brennan, 'Land rights make room for self-rule', *The Australian* (Daily National Newspaper),
 Monday July 31 1995, p. 11.

56 John Rajchman, *Truth and Eros: Foucault, Lacan and the Question of Ethics*, New York and London, 1991,
 p.108.

57 Ibid,. p. 130.

58 Bain Attwood, p. xv. One should note however that much Australian Anthropology remains 'cautious,
 conservative and . . . basically unfashionably empiricist' (J. Morton, '"Crisis, What Crisis?": Australian
 Aboriginal Anthropology, 1988', *Mankind*, Vol. No.1, 1989, p. 7), although some innovative work
 exists, e.g. J. Beckett (ed), *Past and Present*; Morris, *Domesticating Resistance*; J. Marcus (ed), *Writing
 Australian Culture: Text, Society and National Identity*, a special issue of *Social Analysis*, No. 27, 1990.
 Furthermore, while the ingredients of a post-Aboriginalist History are evident in the historiography of
 the last two decades or so, there is little sign of well theorised and well executed work of this nature,
 but see (Bain Attwood's) *The Making of the Aborigines*, and K. Neumann, 'A Postcolonial Writing of

Aboriginal History', *Meanjin*, vol. 51, No. 2, 1990, pp. 277–98. (For helpful discussion of post-Orientalist history, see G. Prakash, 'Writing Post-Orientalist Histories of the Third World: Perspectives from Indian Historiography', *Comparative Studies in Society and History*, vol. 32, No. 2, 1990, pp. 383–408.) And in prehistoric archaeology there has been little change in reconceptualising Aboriginality, but see T. Murray, 'Tasmania and the "Dawn of Humanity"', *Antiquity*, forthcoming, for a consideration of this.

59 Bernard Smith, *The Spectre of Truganini*, Sydney, 1980, pp. 10, 44, as quoted by Attwood.

60 Thomas McEvilley, 'I am, is a Vain Thought', *Art and Discontent: Theory at the Millennium*, McPherson and Company, New York, 1991, p. 115.

Gordon Bennett's Existentialism Pages 65–71

1 Imants Tillers, *Diaspora*, Museum of Contemporary Art, Sydney, 1993, p.36

2 See Jean-Paul Sartre, *Being and Nothingness*, translated Hazel E. Barnes, Philosophical Library, New York, nd, p.222.

3 For a useful summary of Lacan's theories of subjectivity and desire, see Patrick Fuery, *Theories of Desire,* Melbourne University Press, 1995, pp.7-30.

4 In his Redfern address, a Prime Minister of Australia acknowledged for the first time that white Australians had to accept responsibility for the holocaust of colonialism and, in particular, the evils committed against Aborigines and Torres Strait Islanders by European colonisers. The Mabo High Court Ruling overturned the legal concept of *terra nullius* which had for the previous two hundred years legally justified the theft of indigenous land by the European colonisers. These two events have been the most important moments in the relations between Australia's institutions of government and the indigenous populations since colonisation, for even more than the 1967 referendum which gave Aborigines and Torres Strait Islanders the rights of citizenship, and even more than the gradual advancement in indigenous land rights since the 1970s, the Redfern address and the Mabo ruling overturned, in principle at least, two of the most important conceptual cornerstones which had for two hundred years legitimised the oppression of Australia's indigenous populations by a colonial regime.

5 op cit, p.246.

6 op cit, pp.245-246

7 Nikos Papastergiadis, 'The Ends of Migration', *Agenda*, 29, March 1993, pp.7-13.

8 Jung's notion of the shadow and its relation to Bennett's work is discussed in the next chapter.

9 Gordon Bennett, 'Aesthetics and Iconography: An Artist's approach', *Aratjara: The Art of the First Australians*, ed. Bernhard Luthi and Gary Lee, Kunstsammlung Nordrhein-Westfalen, Dusseldorf, 1993, p.89.

Gordon Bennett's Critical Aesthetic Pages 73–94

1 Jacques Lacan, *The Four Fundamental Concepts of Psychoanalysis*, translated Alana Sheridan, ed. Jacqyes-Alain Miller, W.W. Norton & Company, New York, 1981, p.88.

2 Jean Paul Sartre, 'Preface', *The Wretched of the Earth*, Frantz Fanon, translated Constance Farrington, Penguin, Harmondsworth, 1973, p.22.

3 Frantz Fanon, *The Wretched of the Earth*, pp.30-31.

4 Jean Paul Sartre (1948), *Black Orpheus*, trans. S.W. Allen, Editions Gallimard, Paris, n.d., p.11.

5 ibid., pp.7-8.

6 Bennett 'appropriates' Colin McCahon's *The Elias Series*, Philip Guston's *Edge of the City* and Peter Booth's *A Witnessing Mob*. However, as I argue presently, it is debatable whether appropriation is the most appropriate word to describe Bennett's use of and reference to other artist's work.

7 Such as *Authentic Self, Shut Up Bennett (Bad Faith), Nature of the Observer, Kierkegaard*.

8 Jacques Derrida, 'Octobiographies', *The Ear of the Other*, translated Avital Ronel, ed. Chrietie McDonald, University of Nebraska Press, Lincoln, 1988, p.19.

9 However Bennett denies that this was his conscious intention.

10 Michel Foucault, *Madness and Civilisation*, translated Richard Howard, Vintage books, New York, 1973, pp.286-288.

11 Robert Graves (1955), *The Greek Myths*, Penguin Books, Harmondsworth, 1980, 85.*1*

12 Bennett's clearest statement on his debt to Jung's ideas is 'On shadows (of my former self)', which accompanied his September 1995 exhibition at Sutton Gallery, Melbourne.

13 See Bennett's concluding sentence in the accompanying essay.

14 Jacques Derrida, 'Women in the Beehive: A Seminar with Jacques Derrida', *Discourses: Conversations in Postmodern Art and Culture*, ed. Russell Ferguson et al, The MIT Press, Cambridge, 1992, p.122.

15 Bennett derived his image of the landscape from pictures of dissected bowels, thus revealing behind the usual iconic representation of the red interior a grotesque formula.

16 Technically Bennett did not break any Australian laws of copyright, but at the time he was not fully aware of the protocols of Aboriginal ownership.

17 Bob Lingard, interview with Gordon Bennett, 'A Kind of History Painting', *Tension*, 17, August 1989, p.42.

18 Conversation between author and artist, January 1995.

Towards an Australian Postcolonial Art
Pages 97–119

1 'Unhomeliness' wrote Bhabha, 'is the condition of extra-territorial and cross-cultural initiations.' (Homi Bhabha, 'Introduction', *The Location of Culture*, Routledge, London 1994, p.9)

2 Meaghan Morris, 'Panorama The Live, The Dead and The Living', *Island in the Stream.*, ed Paul Foss, Pluto Press, Leichardt, 1988, p.163. However the postmodern world is pervasive rather than invasive. In the totalising post-subject regime of postmodernism, the concept of invasion is anachronistic because there are no points of resistance, no objects or spaces to invade.

3 Fredric Jameson, 'Postmodernism, or the Cultural Logic of Late Capitalism', *New Left Review*, 146, 1984, p.71.

4 Op cit, p.166.

5 See Bhabha's distinction between negotiation and negation in 'The Commitment to Theory', *The Location of Culture*, op. cit. p.25.

6 Letter to the author from Gordon Bennett, 6.4.1994, p.2.

7 Bennett's first use of a black square is in *Untitled* 1989, discussed in the previous chapter, in the black square is all that is left after the whitening of Australia.

8 Imants Tillers (1984), 'In Perpetual Mourning', *Imants Tillers Venice Biennale* 1986, The Visual Arts Board of the Australia Council, Sydney, and Art Gallery of South Australia, Adelaide, 1986, p.19.

9 The contest was at its most blatant in the *Commitments* exhibition organised by the Institute of Modern Art in Brisbane in 1993. The exhibition consisted of collaborative works between Aboriginal and Euro-Australian artists. While on one level Bennett refused to collaborate with Tillers, he authorised an } installation which consisted of the faxes between Tillers and Bennett in which Tillers' requests for collaboration were refused. In other words, Bennett's refusal was predicated on a respect for Tillers' work.

10 The well-known Papunya painter.

11 In this context Bennett's paintings recall Gothic images of martyred saints.

12 Paul Carter, 'Invisible Journeys, Exploration and Photography in Australia 1839–1889', *Island in the Stream*, p.60.

13 See Jean Baudrillard, *America*, translated Chris Turner, Verso, London, 1991.

14 This black area of the painting is drawn from Sigmar Polke's *White Obelisk* (1968).

15 Letter from Bennett to author, 9.8.95, p.1.

16 The installation included several hundred bricks wrapped in newspaper, as well as neon words and other written material.

17 Letter to the author from Gordon Bennett, 1.7.94. p.1.

18 Philip Brophy, 'A Face Without a Place Identity in Australian Contemporary Art Since 1980', *Art & Text*, 16, 1988, p.80.

19 Homi Bhabha, 'Of Mimicry and Man: the Ambivalence of Colonial Discourse', *October*, 28, 1984, p.132.

20 However Bennett does not want to deny the efficacy of essentialist tactics in winning political points, or the real everyday differences between different ethnic cultures. But these are possibilities to which he does not have access.

Biography

Born

1955 Monto, Queensland

Lives and works in Brisbane

Studies

1986–88 Bachelor of Arts (Fine Arts), Queensland College of Art, Brisbane

1995 Australian Network for Art and Technology Summer School, Brisbane

Awards

1991 Moët & Chandon Australian Art Fellowship

1993 McGeorge Fellowship, University of Melbourne

1995 Pine Rivers Art Prize

Logan Art Award for Painting

1996 Anniversary Creative Arts Fellow, Australian National University, Canberra

Video Performances

1994 Performance with 'Object for the Expiation of Guilt', Bellas Gallery, Brisbane

D.U.H! (Down-Under Homi), Sutton Gallery, Melbourne

1995 Performance with 'Object for the Expiation of Guilt (Apple Premiere Mix)', Noosa Regional Gallery, Noosa

Performances

1992–97 Non-Performance, consisting of a 5 year period of systematic refusal to participate in public lecture programmes within Australia

Lectures

1992 Aratjara Symposium, Kunstsammlung Nordrhein-Westfalen, Dusseldorf, Germany, April 24–25th

1993 Inner Land Symposium, 'Art for Co-existence with Earth'

International House of Japan, Tokyo, Nov 11th

1994 Iniva Symposium, 'A New Internationalism', Tate Gallery, London, April 27–28th

Solo Exhibitions

1989 *Gordon Bennett*, Bellas Gallery, Brisbane

1990 *Gordon Bennett*, Bellas Gallery, Brisbane

Psycho(d)rama, Institute of Modern Art, Brisbane

1991 *Gordon Bennett*, Bellas Gallery, Brisbane

Dialogues with Self, Art Gallery of Western Australia

1992 *The Colour Black and Other Histories*, Bellas Gallery, Brisbane

Relative/Absolute, Bellas Gallery, Brisbane

1993 *A Black History*, Sutton Gallery, Melbourne

Painting History, Contemporary Art Centre of South Australia, Adelaide; The Drill Hall,

Canberra

Mirrorama, Ian Potter Gallery, University of Melbourne, Melbourne

How to Cross the Void, Bellas Gallery, Brisbane

1994 *Present Wall*, Installation, Institute Building, Adelaide

How to Cross the Void, Sutton Gallery, Melbourne

Dismember/Remember, Bellas Gallery, Brisbane

Surface Veil, Bellas Gallery, Brisbane

Mirror Mirror (The Inland Sea), Sutton Gallery, Melbourne

1995 *Black: Fear of Shadows*, Bellas Gallery, Brisbane

John Citizen: Works on Paper, Sutton Gallery, Melbourne

1996 *John Citizen: Sacred Cows*, Home Decor (after Margaret Preston)

Group Exhibitions

1987 *Little Masters*, THAT Contemporary Art Space, Brisbane

1988 *Works from the Collection*, MOCA (Museum of Contemporary Art), Brisbane

Australian Art of the Last Twenty Years, MOCA (Museum of Contemporary Art), Brisbane

1989 *Perspecta*, Art Gallery of New South Wales, Sydney

Visual Poetics, MOCA (Museum of Contemporary Art), Brisbane

Collaborations, Bellas Gallery, Brisbane

1990 *Paraculture*, Artists Space, New York, USA

Moët & Chandon Touring Exhibition

Balance 1990: Views, Visions, Influences, Queensland Art Gallery, Brisbane

Adelaide Biennial, Art Gallery of South Australia, Adelaide

Young Contemporaries, Irving Galleries, Sydney

Urban Aboriginal Art, Hogarth Galleries, Sydney

Innovations in Aboriginal Art, Hogarth Galleries, Sydney

Only Life, Bellas Gallery, Brisbane

Tagari Lia: My Family, Contemporary Aboriginal Art 1990– From Australia, Third Eye Centre, Glasgow, UK

You Came to My Country and You Didn't Turn Black, Queensland Museum, Brisbane

Aquisitions 1984–1990, University Art Museum, University of Queensland, Brisbane

Post-Hillshoistism, MOCA (Museum of Contemporary Art, Brisbane

1991 *Aboriginal Art and Spirituality*, High Court of Australia, Canberra

Moët & Chandon Touring Exhibition

Three Artists, Powell Street Gallery, Melbourne

1992 *Tyerabarrbowaryaou: I Shall Never Become a White Man*, Museum of Contemporary Art, Sydney

Southern Crossings: Contemporary Australian Photography, Camerawork, London

Australian Artists In Paris, Parvi: Pour l'Art Visuel, Paris

Works From the Collection, MOCA (Museum of Contemporary Art), Brisbane

Domino 1: Collaborations Between Artists, The University of Melbourne Museum of Art: Ian Potter Gallery, Melbourne

Medium Density: Contemporary Australian Drawings and Photographs, Australian National Gallery, Canberra

Strangers in Paradise: Contemporary Australian Art to Korea, National Museum of Contemporary Art, Seoul

Transgenerations, Queensland Art Gallery, Brisbane

The Ninth Biennale of Sydney: The Boundary Rider, Bond Store 3/4, and Art Gallery of New South Wales, Sydney

1993 *Confess and Conceal: 11 Insights From Contemporary South East Asia and Australia*, Art Gallery of Western Australia, Perth. Touring exhibition to South East Asia

Fifth Australian Sculpture Triennial, Melbourne

Aratjara: Art of the First Australians, Kunstsammlung Nordrhein-Westfalen, Dusseldorf; Hayward Gallery, London; Louisiana Museum of Contemporary Art, Humlebaek, Denmark

Inner-Land: Australian Contemporary Art, Soko Gallery, Tokyo, Japan

Commitments, Institute of Modern Art, Brisbane

Prime Television Painting Prize, Newcastle Regional Art Gallery, Gold Coast City Art Gallery

Gold Coast City Council Conrad Jupiters Art Prize, Gold Coast City Art Gallery

1994 *Identities: Art From Australia*, an International Exchange Exhibition between Australia and Taiwan, Taipei Fine Arts Museum, Wollongong City Gallery, Gold Coast City Gallery

Sweet Damper and Gossip: Colonial Sightings From the Goulburn North East, Benalla Art Gallery and Shepparton Art Gallery in Victoria, Monash University Gallery, Melbourne

Adelaide Installations: incorporating the Adelaide Biennial of Australian Art, various sites, Adelaide

The Fifth Havana Biennale, Cuba

Aussemblage!, Auckland City Art Gallery, Auckland, New Zealand

Landed, Australian National Gallery, Canberra

Faciality, Monash University Gallery, Melbourne

Tyerabarrbowaryaou II, Museum of Contemporary Art, Sydney

Urban Focus: Aboriginal and Torres Strait Islander Art From The Urban Areas of Australia, Australian National Gallery, Canberra

Localities of Desire: Contemporary Art in an International World, Museum of Contemporary Art, Sydney

The Beach, Museum of Modern Art at Heide, Melbourne

1994–95 *Antipodean Currents*, John F Kennedy Center for the Performing Arts, Washington DC, Guggenheim Museum SoHo, New York

Virtual Reality, National Gallery of Australia, Canberra

1995 *Digital Shifts*, Noosa Regional Gallery, Noosa

Pathways 1, Queensland Art Gallery, Brisbane

Transculture, Palazzo Guistinian Lolin, Venice Biennale, Italy; Naoshima Contemporary Art Museum, Naoshima Island, Japan

Seven Histories of Australia, Australian Centre for Contemporary Art, Melbourne

The Wandering Jew: Myth and Metaphor, Jewish Museum of Australia, Melbourne. Regional Touring Exhibition

Lingo: Getting the Picture, Brisbane City Council Art Gallery, Brisbane

Sight Seeing: Views, Tourists, Souvenirs, National Philatelic Centre, Melbourne

Interfaces: Art and Technology, Regional Touring Exhibition hosted by Griffith University, Brisbane

1996 *The Fourth Adelaide Biennial of Australian Art*, Art Gallery of South Australia, Adelaide

Native Titled Now, Tandanya(National Aboriginal Cultural Institute), Adelaide

Blundstone Prize Touring Exhibition

Flagging the Republic, Sherman Galleries Goodhope, Sydney; Regional Touring Exhibition

Systems End — Contemporary Art in Australia, Oxy Gallery, Osaka; Hakone Open-Air Museum Tokyo; Dong Ah Gallery, Seoul

Colonial Post Colonial, Museum of Modern Art at Heide, Melbourne

Perception and Perspective, National Gallery of Victoria, Melbourne

Collections

Museum of Modern Art at Heide, Melbourne

Museum of Contemporary Art, Sydney

Art Gallery of New South Wales, Sydney

Art Gallery of South Australia, Adelaide

Art Gallery of Western Australia, Perth

Queensland Art Gallery, Brisbane

Australian National Gallery, Canberra

Moët & Chandon, Epernay, France

Centre Gallery, Gold Coast Regional Gallery

Brisbane City Council Art Gallery and Museum

Perc Tucker Regional Gallery, Townsville

Stanthorpe Art Gallery, Stanthorpe

University Art Museum, Queensland University, Brisbane

Griffith University, Brisbane

The Flinders University of South Australia, Adelaide

Queensland University of Technology, Brisbane

Museum of Art, University of Melbourne, Melbourne

Vizard Collection, Melbourne

Monash University Gallery, Melbourne

Artbank, Sydney

State Library of Victoria, Melbourne

Brisbane Boys Grammar School, Brisbane

BHP Collection

Queensland Teachers Union, Brisbane

BP Refinery Ltd, Brisbane

Wesfarmers Ltd, Perth

Capalaba State High School, Brisbane

Wavell State High School, Brisbane

Downlands College, Toowoomba Regional Gallery

Pine Rivers Shire Council

Waverley City Gallery, Victoria

University of Technology, Sydney

Benalla Gallery, Victoria

Bibliography

By the Artist

'Aesthetics and Iconography: An Artist's Approach', *Aratjara: Art Of The First Australians*, Catalogue, 1993, Kunstsammlung Nordrhein-Westfalen, Düsseldorf, pp. 85–91

'Re-writing History', *Southern Crossings*, Catalogue, Camerawork, London, 1992, p19–21

Catalogue Statement, *Southern Crossings*, Camerawork, London, 1992, pp. 43–47

Catalogue statement, *Identities: Art From Australia*, 1993, Taipei Fine Arts Museum, Taiwan, pp. 53–55

'On Double Standards: An "Other" Perspective', *Art Monthly Australia*, #47, March, 1992, Canberra, pp. 26–27

Catalogue Statement, *Tyerabarrbowaryaou:I Shall Never Become A White Man*, 1992, Museum of Contemporary Art, Sydney, p. 14

'The Coming of the Light', Catalogue statement, *Balance 1990: Views, Visions, Influences*, 1990, Queensland Art Gallery, Brisbane, pp. 46–47

'Confess Conceal', Catalogue Statement, *Confess And Conceal*, 1993, Art Gallery of Western Australia, Perth, pp. 26–28

Catalogue statement, *Fifth Australian Sculpture Triennial*, 1993, Catalogue Vol No 1, Melbourne, pp. 32–33

Catalogue Statement, *Strangers In Paradise: Contemporary Australian Art To Korea*, 1992, Art Gallery of New South Wales, Sydney, pp. 22–25

Catalogue Statement, *Zero One — Digital Shifts*, Noosa Regional Gallery, 1995, p. 8

'Altered Body Print (Howl)', *A Selection From The Downlands Art Collection; Toowoomba Regional Art Gallery*, Catalogue, 1995, Downlands College, Toowoomba, pp. 19–20

General

Amadio, Nadine, 'Oz in the Global Art Village', *Oz Arts Magazine*, #4,1992, Sydney, pp. 70–71

Anderson, Peter, 'Gordon Bennett', *Art & Text*, #40, September 1991, Art & Text Pty Ltd, Melbourne, p. 94

Barrett-Lennard, John, 'Negotiating a Position', *Adelaide Installations: Adelaide Biennial Of Australian Art*, Catalogue, Vol No 1, 1994, Art Gallery of South Australia, Adelaide, pp. 48–51

Bartlett, Judith, *You Came To My Country And You Didn't Turn Black*, Catalogue, 1990, Queensland Museum, Brisbane

Broadfoot, Keith and Butler, Rex, 'The Fearful Sphere of Australia', *Paraculture*, Catalogue,1990, Artspace, Sydney; Artists Space, New York, pp. 6–14

Buckner, Robin, 'Gordon Bennett', *Art And Design* (Book one),1995, McGraw-Hill Book Company, Sydney, pp. 12–14

Butler, Rex, 'The Pataphysical Aborigine', *Gordon Bennett*, Catalogue, 1992, Moët & Chandon Australian Art
 Foundation, Epernay, France

Butler, Rex, 'Two Readings of Gordon Bennett's The Nine Ricochets' *Eyeline*, #19, Winter/Spring,1992,
 Queensland Art Workers Alliance, Brisbane, pp. 18–23

Cass, Naomi, 'Home Is Where the Heart Is', *The Wandering Jew — Myth And Metaphor*, Catalogue, 1995,
 Jewish Museum of Australia, Melbourne, pp. 18–27

Chapman, Christopher, 'A Discussion with Gordon Bennett — The Inland Sea', *Artonview*, National Gallery
 of Australia, Canberra, Issue No 1, Autumn, 1995, pp. 38–42

Chapman, Christopher, 'Homeboy', *Art & Australia*, Vol 32, No 3, Autumn, 1995, Sydney, p. 442

Crumlin, Rosemary, *Aboriginal Art And Spirituality*, 1991, Collins Dove, North Blackburn, Victoria,
 pp. 143–144

Drury, Nevill, *Images 2: Contemporary Australian Painting*, 1994, Craftsman House, Sydney, pp. 260, 289

Dutkiewicz, Adam, 'Complex and Engaging Imagery', *Adelaide Advertiser*, 25th Feb, 1994

Foggarty, Rebbekah, 'Fusing Cultures', *Dare*, Issue #1, July 1989, Dare Magazine Pty Ltd, Brisbane, pp.
 45–46

Fontannaz, Lucienne, 'Lingo — Getting the Picture', *Lingo — Getting The Picture*, Catalogue, 1995, Brisbane
 City Hall Art Gallery, Brisbane, p. 4, p. 10

Friis-Hansen, Dana and Nanjo, Fumio, 'Gordon Bennett' *Transculture*: La Biennale di Venezia 1995,
 Catalogue, Palazzo Giustinian Lolin (Fondazione Levi), pp. 18–19 and pp. 87–92

Gates, Merryn, 'Collaborations Between Artists', *Domino 1: Collaborations Between Artists*, Catalogue,1992,
 The University of Melbourne Museum of Art, pp. 2–21

Gleissler, Marie, 'Moët & Chandon', *Oz Arts Magazine*, Issue 1, Spring 1991, pp. 54–59

Heathcote, Christopher, 'Postmodern, but with a point to make', *The Age*, 24th Feb, 1993, Melbourne

Hoorn, Jeannette, 'Positioning the Post-Colonial Subject: History and Memory in the Art of Gordon
 Bennett', *Art And Australia*, Vol No 31, #2, Summer, 1993, Sydney, pp. 216–226

Isaacs, Jennifer, 'A Bitter Pill for the White Man (Woman): Tyerabarrbowaryaou at the Museum of
 Contemporary Art', *Art Monthly Australia*, #49, May 1992, Canberra, pp. 6–7

Isaacs, Jennifer, 'Gordon Bennett', *Aboriginality: Contemporary Aboriginal Paintings & Prints*, 1992, University of
 Queensland Press, Brisbane, pp. 53–57

Johnson, Vivien, 'The Unbounded Biennale: Contemporary Aboriginal Art', *Art And Australia*, Vol No 31,
 #1, Spring,1993, Sydney, pp. 49–56

Kirker, Anne, 'Gordon Bennett: Expressions of Constructed Identity', *Artlink*,Vol 10, #1&2,
 Autumn/Winter,1990, Artlink Incorporated, Adelaide, pp. 93–95

Lingard, Bob, 'A Kind of History Painting', *Tension*, #17, August1989, The Xtension Partnership,
 Melbourne, pp. 39–42

Lingard, Bob, 'Psycho(d)rama: De(con)stucting "Settlement"', *Psycho(D)Rama*, Catalogue,1990, Institute of
 Modern Art, Brisbane

Lingard, Bob, 'Painting History', *Painting History*, Catalogue,1993, Contemporary Art Centre of South

Australia, Adelaide

Lingard, Bob and Rizvi, Fazal; '(Re)membering, (Dis)membering "Aboriginality" and the Art of Gordon Bennett', *Third Text*, #26, Spring, 1994, London, pp. 75–89

Lynn, Victoria, 'Introduction: Strangers in Paradise', *Strangers In Paradise: Contemporary Australian Art To Korea*, Catalogue, 1992, The National Museum of Contemporary Art, Seoul, Korea, pp. 12–18

McLean, Ian, 'A Pool of Mirrors: Gordon Bennett's Present Wall', *Adelaide Installations*, Catalogue, Vol No1, 1994, Art Gallery of South Australia, Adelaide, pp. 52–54

McLean, Ian, 'Psycho(d)rama Mirror Line: Reading Gordon Bennett's Installation Mirrorama', *Third Text*, #25, Winter, 1993–94, London, pp. 77–80

Megaw, Ruth and Megaw, Vincent; 'Violent Images of Conquest', *Adelaide Advertiser*, 3rd June, 1993, Adelaide

Moore, Margaret and O'Ferrall, Michael; 'Confess and Conceal', Catalogue, *Confess And Conceal*, 1993, Art Gallery of Western Australia, Perth, pp. 10–17

Morphy, Howard, 'Aratjara', *Art Monthly Australia*, #63, September, 1993, Canberra, pp. 17–18

Namikawa, Emiko, 'Inner-Land', *Inner-Land: Australian Contemporary Art*, Catalogue, 1993, Lunami Gallery, Tokyo and the Art Gallery of New South Wales, Sydney, pp. 4–5

Newton, Gael, 'Gordon Bennett', *Virtual Reality*, Catalogue,1994, National Gallery of Australia, Canberra, pp. 14–15

Nunn, Louise, 'Reflections on a Media Message', *Adelaide Advertiser*, Thursday 17th February, 1994

O'Ferrall, Michael, 'On Other Perspectives', *Gordon Bennett*, Catalogue, 1992, Moët & Chandon Australian Art Foundation, Epernay, France

Papasdergiadis, Nikos, 'Framing the Message', *Third Text*, #24, Autumn, 1993, London, pp. 81–86

Papasdergiadis, Nikos, 'From the Cambridge Expedition to Aratjara and Mabo: The Politics of Representation', *The Complexities of Culture: Hybridity and 'New Internationalism'*, 1994, Cornerhouse, Manchester and London, pp. 25–28

Petelin, George and Hall, Doug, *Transgenerations*, Catalogue, 1992, Queensland Art Gallery, Brisbane, p. 10

Rainbird, Stephen, 'Gordon Bennett', *Selected Australian Works*, Queensland University of Technology Art Collection: 1945–1995, Catalogue, Queensland University of Technology, p. 55

Scott-Mundine, Djon, 'Drawing on Black Reality', *Myriad Of Dreaming: Twentieth Century Aboriginal Art*, Catalogue,1989, Lauraine Diggins Gallery, Malakoff Press,Melbourne, pp. 125–137

Scott-Mundine, Djon, 'Black on Black: An Aboriginal Perspective on Koori Art', The Land, The City: The Emergence of Urban Aboriginal Art, (Special Supplement), *Art Monthly Australia*, #30, May 1990, Canberra, pp. 7–9

Scott-Mundine, Djon, 'If My Ancestors Could See Me Now', *Tyerabarrbowaryaou: I Shall Never Become A White Man*, Catalogue, 1992, Museum of Contemporary Art, Sydney, pp. 4–11

Seear, Lynne, *Australian Perspecta*, Catalogue,1989, Art Gallery of New South Wales, Sydney, pp. 16–17

Sloane, Helen, 'Terra Australis Incognita? — Perspectives on Cultural Identity', *Southern Crossings*, Catalogue, 1992, Camerawork, London, pp. 7–20

Smith, Terry, 'Aboriginal Art Now: Writing Its Variety and Vitality', *Tagari Lia: My Family — Contemporary Aboriginal Art 1990 — From Australia*, Catalogue,1990, Aboriginal Arts Management Association, Redfern, New South Wales; in association with the Third Eye Centre, Glasgow, p. 12

Spendlove, Cherene, *Adelaide Biennial Of Australian Art*, Catalogue, 1990, Art Gallery of South Australia, Adelaide, pp. 20–21

Stanhope, Zara, 'The Territory of the Face', *Faciality*, Catalogue, 1994, Monash University Gallery, Melbourne, pp. 17–21

Thompson, Liz, *Aboriginal Voices: Contemporary Aboriginal Artists, Writers And Performers*, 1990, Simon and Schuster, Brookvale, Australia, pp. 147–153

Williamson, Clare, 'Seven Histories of Australia', *Seven Histories Of Australia*, Catalogue, 1995, Australian Centre for Contempory Art, Melbourne

Zurbrugg, Nicholas, *Visual Poetics: Concrete Poetry And Its Contexts*, Catalogue, 1989, MOCA (Museum of Contemporary Art), Brisbane, p. 52

Zurbrugg, Nicholas, 'Gordon Bennett', *Art & Text*, #44, Jan 1993, Art & Text Pty Ltd, College of Fine Arts, University of New South Wales, Sydney, p. 85

Zurbrugg, Nicholas, 'Gordon Bennett — Between the Lines', *Antipodean Currents*, Catalogue, 1995, The John F Kennedy Center for the Performing Arts, Washington, DC; Guggenheim Museum SoHo, New York, pp. 40–51

List of Colour Plates

Plate 1, 1994, *Altered Body Print (Shadow Figure Howling at the Moon)*, 182 x 182 cm, Acrylic and flashe on canvas, Collection: Private, Photo: Phillip Andrews

Plate 2, 1992, *History Painting (Burn and Scatter)*, 92 x 65 cm, Acrylic and flashe on canvas, Collection: Holmes à Court, Photo: Courtesy Heytesbury

Plate 3, 1992, *History Painting (Excuse My Language)*, 92 x 65 cm, Acrylic and flashe on canvas, Collection: Holmes à Court, Photo: Courtesy Heytesbury

Plate 4, 1989, *Ancestor Figures*, 148 x 236 cm, Oil on canvas, Collection: Private, Photo: Phillip Andrews

Plate 5, 1992, *Self Portrait (Ancestor Figures)*, Size variable, Mixed media, Courtesy Bellas and Sutton Galleries, Photo: Phillip Andrews

Plate 6, 1990, *Self Portrait (But I Always Wanted to be One of the Good Guys)*, 150 x 260 cm, Oil on canvas, Collection: Private, Photo: Phillip Andrews

Plate 7, 1993, *Self Portrait: Interior/Exterior*, Each panel: 187 x 60 x 25 cm, Mixed media, Collection: The Artist, Photo: Phillip Andrews

Plate 8, 1989, *Web of Attrition (Detail No 1)*, One panel of five: 100 x 100 cm, Oil on canvas, Collection: National Gallery of Australia, Canberra, Photo: Phillip Andrews

Plate 9, 1992, *Myth of the Western Man (White Man's Burden)*, 175 x 304 cm, Acrylic on canvas, Collection: Art Gallery of New South Wales, Photo: Vesna Kovac

Plate 10, 1990, *Resurrection (Bloom)*, 37 x 27 cm, Watercolour on paper, Collection: Private, Photo: Phillip Andrews

Plate 11, 1994, *Aborigine Painting (The Inland Sea)*, 216 x 197 cm, Acrylic on canvas, Collection: Private, Photo: Kenneth Pleban

Plate 12, 1994, *The Aboriginalist (Identity of Negation: Flotsam)*, Size variable, Mixed media, Collection: Museum of Modern Art, Heide, Photo: Kenneth Pleban

Plate 13, 1993, *Big Romantic Painting (Apotheosis of Captain Cook)*, 182 x 400 cm, Acrylic on canvas, Collection: University of Melbourne, Photo: Kenneth Pleban

Plate 14, 1993, *Panorama: Cascade (with Floating Point of Identification)*, 137 x 167 cm, Acrylic on linen, Collection: Private, Photo: Vesna Kovac

Plate 15, 1993, *Terra Nullius (Teaching Aid) as far as the Eye Can See*, 175 x 414 cm, Acrylic on canvas, Collection: Private, Photo: Vesna Kovac

Plate 16, 1988, *The Plough*, 130 x 260 cm, Oil and acrylic on canvas, Collection: Private, Photo: Richard Stringer

Plate 17, 1991, *Explorer*, 168 x 125 cm, Oil and acrylic on canvas, Collection: Private, Photo: Richard Stringer

Plate 18, 1993, *Haptic Painting (Explorer: The Inland Sea)*, 177 x 265 cm, Acrylic on canvas, Collection: Private, Photo: Richard Stringer

Plate 19, 1991, *Possession Island*, 162 x 260 cm, Oil and acrylic on canvas, Collection: Private, Photo: Xavier Lavictorie

Plate 20, 1993, *Death of the Ahistorical Subject (Vertigo)*, 182 x 182 cm, Acrylic on linen, Collection: Private, Photo: Richard Stringer

Plate 21, 1993, *Bloodlines*, 182 x 425 cm, Acrylic on linen, wood and rope, Courtesy Bellas and Sutton Galleries, Photo: Richard Stringer

Plate 22, 1994, *Wound*, 92 x 65 cm, Acrylic and flashe on canvas, Collection: The Artist, Photo: Richard Stringer

Plate 23, 1991, *Bounty Hunters*, 37 x 27 cm, Watercolour on paper, Collection: Private, Photo: Phillip Andrews

Plate 24, 1995, *I'm Not Dirt (Empathy)*, 167 x 152.5 cm, Acrylic on canvas, Collection: Parliament House, Canberra, Photo: Courtesy Parliament House, Canberra

Plate 25, 1991, *Valley of Dry Bones*, 37 x 27 cm, Watercolour on paper, Collection: Private, Photo: Phillip Andrews

Plate 26, 1991, *The Small Brown House*, 37 x 27 cm, Watercolour on paper, Collection: Private, Photo: Phillip Andrews

Plate 27, 1989, *The Great Necrophiliac*, 100 x 90 cm, Oil and acrylic on canvas, Collection: Private, Photo: Phillip Andrews

Plate 28, 1995, *Big Baroque Painting (The Inland Sea)*, 220 x 312 cm, Acrylic on canvas, Collection: Queensland University of Technology, Photo: Sam Charlton

Plate 29, 1987, *The Coming of the Light*, Two panels each 152 x 374 cm, Acrylic on canvas, Collection: The Artist, Photo: Gordon Bennett

Plate 30, 1988, *Outsider*, 290 x 180 cm, Oil and acrylic on canvas, Collection: University of Queensland, Photo: Courtesy University of Queensland

Plate 31, 1988, *Echo and Narcissus*, 179.5 x 200 cm, Oil and acrylic on canvas, Collection: Private, Photo: Gordon Bennett

Plate 32, 1991, *Poet and Muse*, 170 x 225 cm, Oil and acrylic on canvas, Collection: Private, Photo: Richard Stringer

Plate 33, 1989, *Terra Nullius*, 75 x 225 cm, Acrylic on canvas, Collection: The Centre Gallery, Gold Coast, Photo: Courtesy The Centre Gallery, Gold Coast

Plate 34, 1989, *Untitled*, Six panels each 30 x 30 cm, Oil and acrylic on canvas, Collection: Museum of Contemporary Art, Sydney, Photo: Richard Stringer

Plates 35, 36, 37, 1989, Far Left: *Triptych (Detail: Requiem)*, 120 x 120 cm, oil on canvas, Centre: *Triptych (Detail: Of Grandeur)*, 200 x 150 cm, oil and photograph on canvas, Above: *Triptych (Detail: Empire)*, 120 x 120 cm, oil on canvas, Collection: Queensland Art Gallery, Photos: Courtesy Queensland Art Gallery

Plate 38, 1990, *The Nine Ricochets (Fall Down Black Fella, Jump Up While Fella)*, 220 x 182 cm, Oil and acrylic on canvas and canvas boards, Collection: Private, Photo: Phillip Andrews

Plate 39, 1993, *Contemplation*, 14.5 x 10.5 cm, Watercolour on paper, Collection: The Artist, Photo: Kenneth Pleban

Plate 40, 1994, *The Recentred Self*, 167 x 137 cm, Acrylic on linen, Collection: The Artist, Photo: Phillip Andrews

Plate 41, 1995, *Performance with Object for the Expiation of Guilt (Apple Premiere Mix)*, Detail of video still, Courtesy Bellas and Sutton Galleries, Photo: Gordon Bennett

Plate 42, 1991, *Interior (Abstract Eye)*, 185 x 185 cm, oil on canvas, Collection: Moët et Chandon, France, Photo: Courtesy Moët et Chandon, France

Plate 43, 1991, *Abstract Mirror*, 185 x 185 cm, oil on canvas, Collection: Private, Photo: Richard Stringer

Plate 44, 1994, *Mirror (Abstract Field)*, 167 x 137 cm, Acrylic on canvas, Collection: Private, Photo: Kenneth Pleban

Plate 45, 1994, *Painting for a New Republic (The Inland Sea)*, 232 x 507 cm, Acrylic on canvas, Collection: Art Gallery of Western Australia, Photo: Kenneth Pleban

Plate 46, 1993, *Mirror Line*, Mixed media, Site-specific installation, University of Melbourne, Photo: Kenneth Pleban

Plate 47, 1994, *Present Wall*, Mixed media, Site-specific installation, Institute Building, Adelaide, Photo: Clayton Glen

Plate 48, 1995, *Im Wald (Divided Unity)*, 220 x 312 cm, Acrylic on canvas, Collection: Private, Photo: Sam Charlton

List of Black and White Figures

Figure 1, 1992, *Gone Primitive*, 23 x 16 cm, Book, photograph, plastic, cord, Collection: Private, Photo: Gordon Bennett

Figure 2, 1992, *Self Portrait (Vessel)*, Size variable, Mixed media, Courtesy Bellas and Sutton Galleries, Photo: Gordon Bennett

Figure 3, 1991, *Panorama (Stream)*, 130 x 162 cm, Oil and acrylic on canvas, Collection: Private, Photo: Xavier Lavictorie

Figure 4, 1988, *Untitled (Detail of Triptych)*, 38.5 x 57.5 cm, Mixed media on paper, Collection: Queensland Art Gallery, Photo: Gordon Bennett

Figure 5 and 6, 1990, *Psycho(d)rama. (Detail from installation)*, Size variable, Mixed media, Courtesy Bellas and Sutton Galleries, Photo: Grace and Don Bennett

Figure 7, 1968, *Untitled*, 26 x 35.5 cm, Mixed media, Collection: The Artist, Photo: Richard Stringer

Figure 8, 1987, *The Persistence of Language*, (detail of right panel), 152 x 137 cm, Acrylic on canvas, Collection: Art Gallery of Western Australia, Photo: Courtesy Art Gallery of Western Australia

Figure 9 and 10, 1993–94, *Home Sweet Home*, Two panels each: 27.5 x 19 cm, Watercolour and pencil on paper, Collection: Private, Photo: Gordon Bennett

Figure 11 and 12, 1993–94, *Shadow Monster from the Id*, Two panels each: 27.5 x 19 cms, Watercolour and pencil on paper, Collection: Private, Photo: Gordon Bennett

Figure 13, 1994, *Altered Body Print (Howl)*, 150.5 x 103.5 cm, Acrylic on paper, Collection: Downlands Toowoomba, Photo: Courtesy Downlands College

Figure 14, 1994, *Surface Veil*, 38 x 38 cm, Mixed media on paper, Collection: The Artist, Photo: Richard Stringer

Figure 15, 1988, *Prologue: They Sailed Slowly Nearer*, 118 x 198 cm, Oil on canvas., Collection: Museum of Modern Art, Heide (Baillieu Myer), Photo: John Brash

Figure 16, 1991, *Psychotopographical Landscape*, (Arrest). 100 x 100 cm, Oil on canvas, Collection: Private, Photo: Richard Stringer

Figure 17, 1992, *Relative/Absolute (The Name)*, 46 x 55 cm, Acrylic and flashe on canvas, Collection: The Artist, Photo: Gordon Bennett

Figure 18, 1991, *Relative/Absolute (Man + Woman)*, 116 x 195.5 cm, Acrylic and flashe on canvas and wood, Collection: The Artist, Photo: Gordon Bennett

Figure 19, 1989, *Australian Icon (Notes on Perception No 1)*, 76 x 57 cm, Oil and acrylic on paper, Collection: Private, Photo: Gordon Bennett

Figure 20, 1989, *Australian Icon, (Notes on Perception No 6)*, 66 x 56 cm, Acrylic on paper, Collection: Private, Photo: Gordon Bennett

Figure 21, 1995, *If Banjo Paterson Was Black*, Size variable, Mixed media, Collection: Queensland Art Gallery, Photo: Sam Charlton

Figure 22, 1994, *Daddy's Little Girl 2*, 40 x 30 cm, Acrylic on wood, Collection: Private, Photo: Gordon Bennett

Figure 23, 1993, *Man with Whip and Shadow (Stairway to Heaven)*, 50.5 x 40 cm, Acrylic on canvas, Courtesy Bellas and Sutton Galleries, Photo: Gordon Bennett

Figure 24, 1993, *Running Man and Shadow*, 50.5 x 40 cm, Acrylic on canvas, Courtesy Bellas and Sutton Galleries, Photo: Gordon Bennett

Figure 25, 1993, *Through the Void (Diving Board)*, 30 x 20 cm, Soft ground etching on paper, Courtesy Bellas and Sutton Galleries, Photo: Richard Stringer

Figure 26, 1993, *Ask a Policeman*, 30 x 20 cm, Soft ground etching on paper, Courtesy Bellas and Sutton Galleries, Photo: Richard Stringer

Figure 27, 1994, *Couldn't be Fairer*, 40 x 30 cm, Acrylic on wood, Collection: Private, Photo: Kenneth Pleban

Figure 28, 1992, *Untitled (Nuance)*, 85 x 275 cm overall, Photographs and acrylic on foamcore, Courtesy Bellas and Sutton Galleries, Photo: Richard Stringer

Figure 29, 1989, *Siddhartha's Dreaming*, 100 x 100 cm, Oil on canvas, Collection: Private (destroyed by fire), Photo: Gordon Bennett

Figure 30, 1992, *Fig One (Gulf)*, 130 x 324 cm, Oil and acrylic on canvas, Collection: Art Gallery of South Australia, Photo: Courtesy of Art Gallery of South Australia

Figure 31, 1994, *Men with Weapons (Corridor)*, 89 x 232 cm, Acrylic on linen, Collection: Private, Photo: Gordon Bennett

Figure 32, 1993, *Explorer (The Inland Sea)*, 45.5 x 61 cm, Woodcut on Japanese paper, Courtesy Bellas and Sutton Galleries, Photo: Gordon Bennett

Figure 33, 1995, *Nature of the Observer*, 58 x 38 cm, Mixed media on paper, Collection: Private, Photo: Kenneth Pleban

Figure 34, 1988, *Self Portrait*, 179 x 175 cm, Oil on canvas, Collection: The Artist, Photo: Gordon Bennett

Figure 35, 1988, *Requiem for a Self Portrait*, 175 x 179 cm, Mixed media on canvas, Collection: The Artist, Photo: Gordon Bennett

Figure 36, 1993, *Explorer and Companion (The Inland Sea)*, 130 x 162 cm, Acrylic on canvas, Collection: Private, Photo: Vesna Kovac

Figure 37, 1988, *Landscape Painting*, 105 x 225 cm, Oil and acrylic on canvas, Collection: Private, Photo: Gordon Bennett

Figure 38, 1994, *Altered Body Print (Purity of Hybrids)*, 183 x 162 cm, Acrylic on canvas, Courtesy Bellas and Sutton Galleries, Photo: Gordon Bennett

Figure 39, 1994, *Mirror (Altered Body Print: Dismember/ Remember 2)*, 167 x 101 cm, Acrylic on canvas, Collection: Private, Photo: Kenneth Pleban

Figure 40, 1995, *Mirror (Interior / Exterior) Volkgeist*, 167 x 137 cm, Acrylic on canvas, Courtesy Bellas and Sutton Galleries, Photo: Sam Charlton